DAVID BUSCH'S COMPACT

CANON®
EOS REBEL
T3i/600D

David D. Busch

Course Technology PTR
A part of Cengage Learning

COURSE TECHNOLOGY
CENGAGE Learning™

Australia, Brazil, Japan, Korea, Mexico, Singapore, Spain, United Kingdom, United States

COURSE TECHNOLOGY
CENGAGE Learning™

David Busch's Compact Field Guide for the Canon® EOS Rebel T3i/600D

David D. Busch

Publisher and General Manager, Course Technology PTR:
Stacy L. Hiquet

Associate Director of Marketing:
Sarah Panella

Manager of Editorial Services:
Heather Talbot

Marketing Manager:
Jordan Castellani

Executive Editor:
Kevin Harreld

Project Editor:
Jenny Davidson

Series Technical Editor:
Michael D. Sullivan

Interior Layout Tech:
Bill Hartman

Cover Designer:
Mike Tanamachi

Indexer:
Katherine Stimson

Proofreader:
Sara Gullion

Course Technology, a part of Cengage Learning
20 Channel Center Street
Boston, MA 02210
USA

Library of Congress Control Number: 2011924488

ISBN-13: 978-1-4354-6032-4

ISBN-10: 1-4354-6032-4

Cengage Learning is a leading provider of customized learning solutions with office locations around the globe, including Singapore, the United Kingdom, Australia, Mexico, Brazil, and Japan. Locate your local office at:
international.cengage.com/region.

Cengage Learning products are represented in Canada by Nelson Education, Ltd.

For your lifelong learning solutions, visit **courseptr.com**.

Visit our corporate Web site at **cengage.com**.

Printed in the United States of America
1 2 3 4 5 6 7 13 12 11

Contents

Introduction

Throw away your cheat-sheets and command cards! Are you tired of squinting at tiny color-coded tables on fold-out camera cards? Do you wish you had the most essential information extracted from my comprehensive *David Busch's Canon EOS Rebel T3i/600D Guide to Digital SLR Photography* in a size you could tuck away in your camera bag? I've condensed the basic reference material you need in this handy, lay-flat book, *David Busch's Compact Field Guide for the Canon EOS Rebel T3i/600D.* In it, you'll find the explanations of *why* to use each setting and option—information that is missing from the cheat-sheets and the book packaged with the camera. You *won't* find the generic information that pads out the other compact guides. I think you'll want to have both this reference and my full-sized guide—one to help you set up and use your EOS Rebel T3i or EOS 600D, and the other to savor as you master the full range of things this great camera can do.

About the Author

With more than a million books in print, **David D. Busch** is the world's #1 selling digital camera guide author, and the originator of popular digital photography series like *David Busch's Pro Secrets, David Busch's Quick Snap Guides,* and *David Busch's Guides to Digital SLR Photography.* As a roving photojournalist for more than 20 years, he illustrated his books, magazine articles, and newspaper reports with award-winning images. Busch operated his own commercial studio, suffocated in formal dress while shooting weddings-for-hire, and shot sports for a daily newspaper and upstate New York college. His photos and articles have appeared in *Popular Photography & Imaging, Rangefinder, The Professional Photographer,* and hundreds of other publications. He's also reviewed dozens of digital cameras for CNet and *Computer Shopper,* and his advice has been featured on NPR's *All Tech Considered.* Visit his website at www.dslrguides.com/blog.

Chapter 1

Quick Setup Guide

This chapter contains the essential information you need to get your Canon EOS Rebel T3i/600D prepped and ready to go. You'll learn how to use a few of the basic controls and features, and how to transfer your photos to your computer. If you want a more complete map of the functions of your camera, skip ahead to Chapter 2.

Pre-Flight Checklist

The initial setup of your Rebel T3i is fast and easy. You just need to learn a few controls, charge the battery, attach a lens, and insert a Secure Digital card.

Charging the Battery

When the battery is inserted into the LC-E8 charger properly (it's impossible to insert it incorrectly), a Charge light begins glowing orange-red. When the battery completes the charge, the lamp turns green, approximately two hours later. When the battery is charged, remove it from the charger, flip the lever on the bottom of the camera, and slide the battery in. (See Figure 1.1.) To remove the battery, you must press a white lever, which prevents the pack from slipping out when the door is opened.

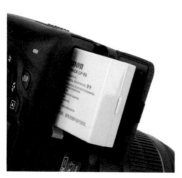

Figure 1.1
Insert the battery in the camera; it only fits one way.

Introducing Menus and Navigation Controls

You'll find descriptions of most of the controls used with the Rebel T3i in Chapter 2, which provides a complete "roadmap" of the camera's buttons and dials and switches. However, you may need to perform a few tasks during this initial setup process, and most of them will require the MENU button, Main Dial, and the cross keys navigation pad.

- **MENU button.** It's located to the upper-left corner of the LCD monitor on the back of the camera. When you want to access a menu, press it. To exit most menus, press it again.

- **Main Dial.** Near the shutter release on top of the camera, used to navigate between top-level menus and change camera settings.

- **Cross keys pad.** A thumbpad-sized button with indentations at the North, South, East, and West "navigational" positions, plus a button in the center marked "SET" (see Figure 1.2). With the T3i, the cross keys are used extensively to navigate among menus on the LCD or to choose one of the focus points, to advance or reverse display of a series of images during picture review. The SET button is used to confirm your choices. Each key has a secondary function as well: Up: white balance; Down: Picture Style; Left: Drive mode; Right: AF mode.

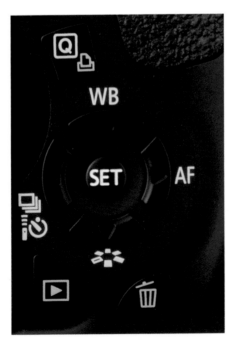

Figure 1.2

The cross keys pad has four directional buttons for navigating up/down/left/right, and a SET button to confirm your selection.

Setting the Clock

The first time you use the Rebel T3i, it may ask you to enter the time and date. (This information may have been set by someone checking out your camera on your behalf prior to sale.) Just follow these steps:

1. Press the MENU button, located in the upper-left corner of the back of the T3i.

2. Rotate the Main Dial (near the shutter release button on top of the camera) until the Setup 2 menu is highlighted. It's marked by a wrench with two dots next to it.

3. Use the up/down cross keys to move the highlighting down to the Date/Time entry.

4. Press the SET button in the center of the keypad to access the Date/Time setting screen.

5. Use the left/right cross keys to select the value you want to change. When the gold box highlights the month, day, year, hour, minute, or second format you want to adjust, press the SET button to activate that value. A pair of up/down pointing triangles appears above the value.

6. Press the up/down cross keys to adjust the value up or down. Press the SET button to confirm the value you've entered.

7. Repeat steps 5 and 6 for each of the other values you want to change. The date format can be switched from the default mm/dd/yy to yy/mm/dd or dd/mm/yy.

8. When finished, navigate with the right cross key to select either OK (if you're satisfied with your changes) or Cancel (if you'd like to return to the Set-up 2 menu screen without making any changes). Press SET to confirm your choice.

9. When finished setting the date and time, press the MENU button to exit.

Mounting the Lens

If your T3i has no lens attached, you'll need to mount one before shooting:

1. Select the lens and loosen (but do not remove) the rear lens cap.

2. Remove the body cap on the camera by rotating the cap towards the release button.

3. Once the body cap has been removed, remove the rear lens cap from the lens, set it aside, and then mount the lens on the camera by matching the alignment indicator on the lens barrel (red for EF lenses and white for EF-S lenses) with the red or white dot on the camera's lens mount. (See Figure 1.3.) Rotate the lens away from the shutter release until it seats securely.

4. Set the focus mode switch on the lens to AF (autofocus). If the lens hood is bayoneted on the lens in the reversed position (which makes the lens/hood combination more compact for transport), twist it off and remount with the "petals" facing outward. A lens hood protects the front of the lens from accidental bumps, and reduces flare caused by extraneous light arriving at the front element of the lens from outside the picture area.

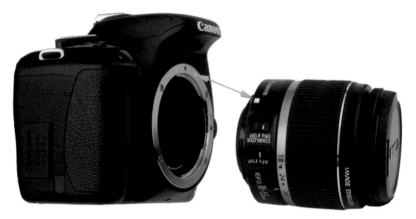

Figure 1.3 Match the indicator on the lens with the white or red dot on the camera mount to properly align the lens with the bayonet mount.

Adjusting Diopter Correction

Those of us with less than perfect eyesight can often benefit from a little optical correction in the viewfinder. Your contact lenses or glasses may provide all the correction you need, but if you are a glasses wearer and want to use the Rebel T3i without your glasses, or use your glasses with your camera and can benefit from some additional correction, you can take advantage of the camera's built-in diopter adjustment. It can be varied from –3 to +1 correction. Press the shutter release halfway to illuminate the indicators in the viewfinder, then rotate the adjacent diopter adjustment wheel (see Figure 1.4) while looking through the window until the indicators appear sharp.

If the available correction is insufficient, Canon offers 10 different Dioptric Adjustment Lens Series E correction lenses for the viewfinder window. If more than one person uses your T3i, and each requires a different diopter setting, you can save a little time by noting the number of clicks and direction (clockwise to increase the diopter power; counterclockwise to decrease the diopter value) required to change from one user to the other. There are 18 detents in all.

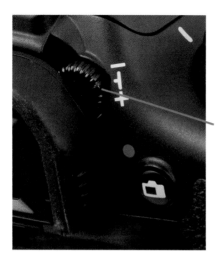

Figure 1.4
Viewfinder
diopter correction
from –3 to +1
can be dialed in.

*Diopter correction
wheel*

Inserting and Formatting a Secure Digital Card

Slide the door on the right side of the body toward the back of the camera to release the cover, and then open it. (You should only remove the memory card when the camera is switched off, but the T3i will remind you if the door is opened while the camera is still writing photos to the memory card.)

Insert the memory card with the label facing the back of the camera, as shown in Figure 1.5, oriented so the edge with the gold contacts goes into the slot first.

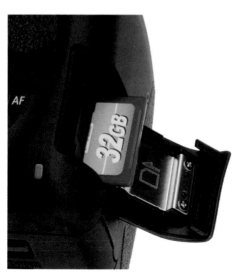

Figure 1.5
The memory
card is inserted
with the label
facing the back of
the camera.

Close the door, and your pre-flight checklist is done! (I'm going to assume you remember to remove the lens cap when you're ready to take a picture!) When you want to remove the memory card later, just press the memory card edge, and it will pop right out.

I recommend formatting the memory card before each shooting session, to ensure that the card has a fresh file system, and doesn't have stray files left over. Format *only* when you've transferred all the images to your computer, of course. To format a memory card, press the MENU button, rotate the Main Dial, located on top of the camera, just behind the shutter release button (or use the left/right cross keys), choose the Set-up menu 1 (which is represented by a wrench icon with a single dot next to it), use the up/down cross keys to navigate to the Format entry, and press the SET button in the center of the cross key pad to access the Format screen. Press the left/right cross keys again to select OK and press the SET button one final time to begin the format process.

Selecting a Shooting Mode

You can choose a shooting method from the Mode Dial located on the top right of the Canon EOS Rebel T3i. (See Figure 1.6.) There are eight Basic Zone shooting modes, plus Movie which Canon further subdivides into Image Zone modes—Portrait, Landscape, Close-up, Sports, and Night Portrait—and automatic Basic Zone modes—Scene Intelligent Auto, Flash Off, and Creative Auto. In any of these modes, the camera makes virtually all the decisions for you (except when to press the shutter). There are also five Creative Zone modes,

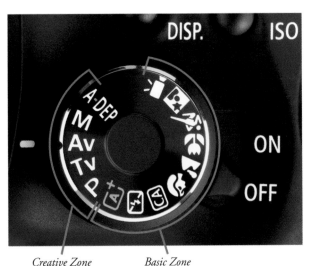

Figure 1.6
Choose Basic Zone and Creative Zone options from the Mode Dial.

Creative Zone *Basic Zone*

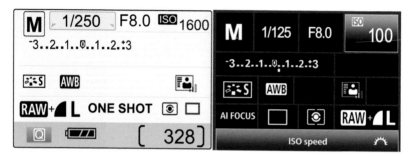

Figure 1.7 The shooting setting screen (left); quick control screen (right).

which allow you to provide input over the exposure and settings the camera uses. The current mode is displayed on the shooting setting screen (left, Figure 1.7). Press the DISP button to show this screen if it is not visible.

Canon has started referring to the true Scene settings (Portrait, Landscape, Close-up, Sports, and Night Portrait) as "Image Zone" modes, and the other three automatic modes (Scene Intelligent Auto, Flash Off, and Creative Auto) as Basic Zone modes (a term formerly applied to all the Basic Zone and Image Zone modes). Because these automatic modes share many characteristics, I'm going to stick with the original Basic Zone nomenclature after I've explained the functions of each in this chapter.

Choosing a Creative Zone Mode

Creative Zone modes let you apply a little more creativity to your camera's settings. These modes are indicated on the Mode Dial by letters P, Tv, Av, M, and A-DEP.

- **A-DEP (Automatic depth-of-field).** Choose this mode if you want to allow the T3i to select an f/stop that will maximize depth-of-field for the subjects in the frame as it adjusts focus and selects an appropriate shutter speed.

- **M (Manual).** Select when you want full control over the shutter speed and lens opening, either for creative effects or because you are using a studio flash or other flash unit not compatible with the T3i's automatic flash metering.

- **Av (Aperture-priority).** Choose when you want to use a particular lens opening, especially to control sharpness or how much of your image is in focus. The T3i will select the appropriate shutter speed for you. Av stands for *aperture value*.

- **Tv (Shutter-priority).** This mode (Tv stands for *time value*) is useful when you want to use a particular shutter speed to stop action or produce creative blur effects. The T3i will select the appropriate f/stop for you.

- **P (Program).** This mode allows the T3i to select the basic exposure settings, but you can still override the camera's choices to fine-tune your image.

Quick Control Screen: Creative Zone Modes

The T3i provides a fast-access quick control screen that lets you change some settings when the shooting settings display is shown on the screen, as seen at left in Figure 1.7 (press the INFO button to the left of the viewfinder window if you want to make the display visible). The available adjustments depend on what Creative Zone or Basic Zone exposure mode you're using. In Creative Zone modes, you can adjust many different parameters, such as white balance, Picture Style, or ISO sensitivity, by pressing the Q button to produce a display similar to the one shown at right in Figure 1.7, ISO sensitivity. (All these adjustments will be discussed later in this chapter and the next one.) Just follow these steps:

1. Press the Q button to produce the quick control screen shown in Figure 1.7.

2. Use the cross keys to navigate to the parameter you want to change.

3. When the parameter is highlighted, you can rotate the Main Dial to change it, or you can press the SET button to produce a screen like those shown in Figures 1.11 and 1.12 later in this chapter, which displays all the options for that parameter. An option can then be highlighted with the cross keys, and confirmed by pressing the SET button.

4. Exit the quick control screen by pressing the Q button again, or tapping the shutter release button.

Choosing a Basic Zone Mode

The eight Basic Zone modes, plus Movie, can be selected by rotating the Mode Dial on the top right of the Rebel T3i to the appropriate icon:

- **Scene Intelligent Auto/Full Auto.** In this mode, marked with a green icon, the EOS T3i makes all the exposure decisions for you, and will pop up the flash if necessary under low-light conditions.

- **Flash Off.** This mode is like Scene Intelligent Auto with the flash disabled. You'll want to use it in museums and other locations where flash is forbidden or inappropriate. It otherwise operates exactly like the auto setting but disables the pop-up internal flash unit.

- **CA.** This Creative Auto mode is basically the same as the Full Auto option, but, allows you to change the brightness and other parameters of the image, as well as use the Ambience options I'll describe later in this chapter.

- **Portrait.** Use this mode when you're taking a portrait of a subject standing relatively close to the camera and want to de-emphasize the background, maximize sharpness, and produce flattering skin tones.

- **Landscape.** Select this mode when you want extra sharpness and rich colors of distant scenes.

- **Close-up.** This mode is helpful when you are shooting close-up pictures of a subject from about one foot away or less.

- **Sports.** Use this mode to freeze fast-moving subjects.

- **Night Portrait.** Choose this mode when you want to illuminate a subject in the foreground with flash, but still allow the background to be exposed properly by the available light. Be prepared to use a tripod or an image-stabilized (IS) lens to reduce the effects of camera shake.

- **Movie.** Use this mode to shoot videos in Live View.

Quick Control Screen: Basic Zone Modes

When using Basic Zone modes, your options are different. When you activate the quick control screen by pressing the quick control button, one of several different screens will appear on your LCD.

Scene Intelligent Auto/Auto (No Flash)

In either of these modes, a screen like the one shown in Figure 1.8 will pop up. Your only choices are Single shooting and Self-timer/10 Second Remote Control. Rotate either the Main Dial or the left/right cross keys to toggle between these two options. Press the quick control button again to exit.

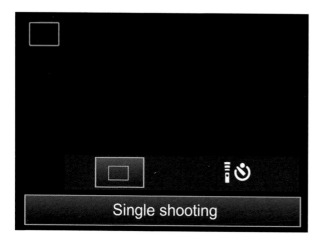

Figure 1.8
Quick control screen in Scene Intelligent Auto/ Auto (No Flash) modes.

Creative Auto Mode

When the Mode Dial is set to Creative Auto, a screen like the one shown in Figure 1.9 appears. You can then do one of three things:

- **Change shooting parameters by ambience.** When the top box on the screen is highlighted, it will display the most recent "ambience" setting you've selected (Standard, unless you've made a change). Ambience is a type of picture style that adjusts parameters like sharpness or color richness to produce a particular look.

 - Press the left/right cross key buttons or rotate the Main Dial and select from among: Vivid, Soft, Warm, Intense, Cool, Brighter, Darker, or Monochrome.

 - Once you've selected your ambience, if you want to change its intensity, press the down cross key to highlight Effect (either Low, Standard, or Strong).

 - You can then rotate the Main Dial to change the Effect to Low, Standard, or Strong. Press the quick control button to exit.

- **Press the down cross key to highlight Background: Blurred↔Sharp.** Then, rotate the Main Dial to adjust the amount of background blurring. The T3i will try to use a larger f/stop to reduce depth-of-field and blur the background, or a smaller f/stop and increased depth-of-field to sharpen the background.

- **Press the down cross key to highlight Drive mode/Flash firing.** Then press the SET button to pop up the Drive mode/Flash firing screen. In this screen, you can rotate the Main Dial to change among the various drive modes, or use the left/right cross key buttons to switch among flash modes.

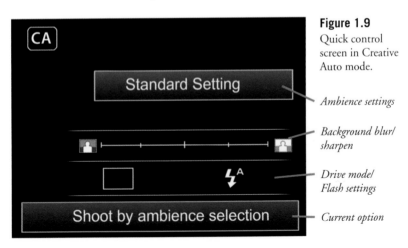

Figure 1.9

Quick control screen in Creative Auto mode.

Ambience settings

Background blur/ sharpen

Drive mode/ Flash settings

Current option

Other Basic Zone Modes

When you select one of the other Basic Zone modes, you'll see a screen similar to Figure 1.10, which pictures the Landscape version. Your options are similar to those in Creative Auto mode:

- **Change shooting parameters by ambience.** When the top box on the screen is highlighted, it will display the most recent "ambience" setting you've selected.

 - Press the left/right cross key buttons or rotate the Main Dial and select from among: Vivid, Soft, Warm, Intense, Cool, Brighter, Darker, or Monochrome, the same choices available in Creative Auto mode.

 - Once you've selected your ambience, if you want to change its intensity, press the down cross key to highlight Effect, and choose Low, Standard, or Strong.

 - You can then rotate the Main Dial to change the Effect to Low, Standard, or Strong. Press the quick control button to exit.

- **Press the down cross key to highlight Default Settings.** This option is available only if you're using Portrait, Landscape, Close-up, and Sports modes. The prompt in the blue box at the bottom of the screen will change to Shoot by Lighting or Scene Type. You can then rotate Main Dial to cycle through Default setting, Daylight, Shade, Cloudy, Tungsten Light, Fluorescent Light, or Sunset. You can also press the SET button and see a menu listing each of these options simultaneously.

- **Press the down cross key to highlight Drive mode/Self-timer.** In this screen, you can press the left/right cross keys or rotate the Main Dial o switch between the available drive mode (either Single shot, or Continuous shooting, depending on the Basic Zone mode selected) and 10 Second Self-timer/Remote.

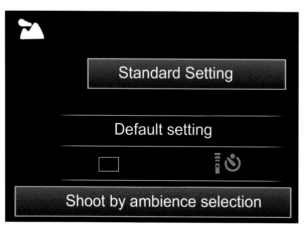

Figure 1.10

Quick control screen in other Basic Zone modes.

PREVIEW AMBIENCE

If you set ambience in Live View mode, the T3i will provide a preview image that simulates the effect your ambience setting will have on the finished image.

Find your desired ambience in Table 1.1.

Table 1.1 Selecting Ambience

Ambience Setting	Effect
Standard	This is the customized set of parameters for each Basic Zone mode, each tailored specifically for Portrait, Landscape, Close-Up, Sports, or other mode.
Vivid	Produces a look that is slightly sharper and with richer colors for the relevant Basic Zone mode.
Soft	Reduced sharpness for adult portraits, flowers, children, and pets.
Warm	Warmer, soft tones. An alternative setting for portraits and other subjects that you want to appear both soft and warm.
Intense	Darker tones with increased contrast to emphasize your subject. This setting is great for portraits of men.
Cool	Darker, cooler tones. Use with care on human subjects, which aren't always flattered by the icier look this setting can produce.
Brighter	Overall lighter image with less contrast.
Darker	Produces a darker image.
Monochrome	Choose from black-and-white, sepia, or blue (cyan-otype) toning.

Choosing a Metering Mode

You might want to select a particular metering mode for your first shots, although the default Evaluative metering (which is set automatically when you choose a Basic Zone mode) is probably the best choice as you get to know your camera. To change metering modes, you'll need to use the T3i's menu system or the quick control screen.

Press the MENU button and navigate to the Shooting 2 menu (a camera icon with two dots next to it). Press the down cross key to highlight Metering mode and press SET. A screen pops up on the LCD offering four choices. Use the left/right cross keys to highlight the choice you want. Then press the SET button to confirm your choice. The options are shown in Figure 1.11:

- **Evaluative metering.** The standard metering mode; the T3i attempts to intelligently classify your image and choose the best exposure based on readings from 63 different zones in the frame, with emphasis on the autofocus points.

- **Partial metering.** Exposure is based on a central spot, roughly nine percent of the image area.

- **Spot metering.** Exposure is calculated from a smaller central spot, about 3.8 percent of the image area.

- **Center-weighted averaging metering.** The T3i meters the entire scene, but gives the most emphasis to the central area of the frame.

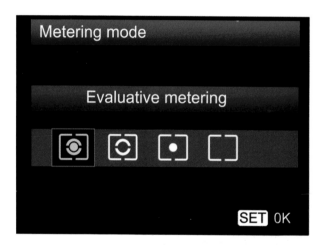

Figure 1.11

Metering modes (left to right) Evaluative, Partial, Spot, Center-weighted.

Choosing a Focus Mode

You can easily switch between automatic and manual focus by moving the AF/MF switch on the lens mounted on your camera. However, if you're using a Creative Zone shooting mode, you'll still need to choose an appropriate focus mode. If you're using a Basic Zone mode, the focus method is set for you automatically.

To set the focus mode, you must first have set the lens to the AF position (instead of the manual focus MF position). Then press the AF button (it's the right cross key) on the back of the camera repeatedly until the focus mode you want is selected (see Figure 1.12). Finally, press SET to confirm your focus mode. The three choices available in Creative Zone modes are as follows:

- **One-Shot.** This mode, sometimes called *single autofocus*, locks in a focus point when the shutter button is pressed down halfway and the focus confirmation light glows in the viewfinder. The focus will remain locked until you release the button or take the picture. If the camera is unable to achieve sharp focus, the focus confirmation light will blink. This mode is best when your subject is relatively motionless. Portrait, Night Portrait, and Landscape Basic Zone modes use this focus method exclusively.

- **AI Servo.** This mode, sometimes called *continuous autofocus*, sets focus when you partially depress the shutter button, but continues to monitor the frame and refocuses if the camera or subject is moved. This is a useful mode for photographing sports and moving subjects. The Sports Basic Zone mode uses this focus method exclusively.

- **AI Focus.** In this mode, the T3i switches between One-Shot and AI Servo as appropriate. That is, it locks in a focus point when you partially depress the shutter button (One-Shot mode), but switches automatically to AI Servo if the subject begins to move. This mode is handy when photographing a subject, such as a child at quiet play, which might move unexpectedly. The Flash Off Basic Zone mode uses this focus method.

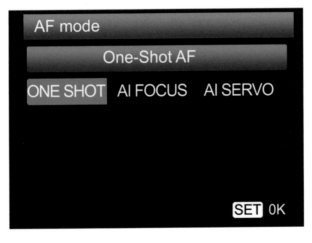

Figure 1.12

Set Autofocus mode.

Selecting a Focus Point

The Canon EOS Rebel T3i uses nine different focus points to calculate correct focus. In A-DEP, or any of the Basic Zone shooting modes, the focus point is selected automatically by the camera. In the other Creative Zone modes, you can allow the camera to select the focus point automatically, or you can specify which focus point should be used.

There are several methods to set the focus point manually. You can press the AF point selection button on the back of the camera (it's in the upper-right corner), and choose a zone from the AF point selection screen that appears in the viewfinder and which pops up when you press the DISP button. (See Figure 1.13.) Press the SET button to toggle between automatic focus point selection (the camera does it for you) or manual focus point selection (you need to specify the point yourself). In Manual selection mode, the cross keys are used to highlight the point you want to use. Press the AF point selection button again (or just tap the shutter release button) to confirm your choice and exit.

Or, you can look through the viewfinder, press the AF point selection button, and rotate the Main Dial to move the focus point to the zone you want to use. The focus point will cycle among the edge points counterclockwise (if you turn the Main Dial to the left) or clockwise (if you spin the Main Dial to the right), ending/starting with the center focus point/all nine focus points. (See Figure 1.13.)

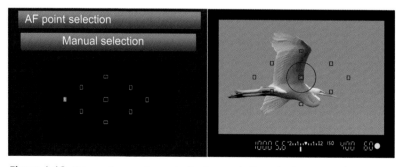

Figure 1.13 Select a focus point and selection mode from the AF point selection screen (left) or choose the focus point while looking through the viewfinder (right).

Adjusting White Balance and ISO

If you like, you can custom-tailor your white balance (color balance) and ISO sensitivity settings. To start out, it's best to set white balance (WB) to Auto, and ISO to ISO 100 or ISO 200 for daylight photos, and ISO 400 for pictures in dimmer light. You can adjust either one now by pressing the WB button (the up cross key) (for white balance) or the ISO button (just aft of the Main Dial) and then using the cross keys to navigate until the setting you want appears on the LCD.

Using the Self-Timer

If you want to set a short delay before your picture is taken, you can use the self-timer. Press the drive/left cross key button and then press the right cross key to select from either the 10-second self-timer (which also can be used with the optional RC-1, RC-5, and RC-6 infrared remote controls), 2-second self-timer or Self-timer: Continuous, which allows you to press the up/down cross keys or rotate the Main Dial to specify a number of shots to be taken (from 2 to 10) once the timer runs its course (see Figure 1.14). Press the SET button to confirm your choice, and a self-timer icon will appear on the shooting settings display on the back of the Rebel T3i. Press the shutter release to lock focus and start the timer. The self-timer lamp will blink and the beeper will sound (unless you've silenced it in the menus) until the final two seconds, when the lamp remains on and the beeper beeps more rapidly.

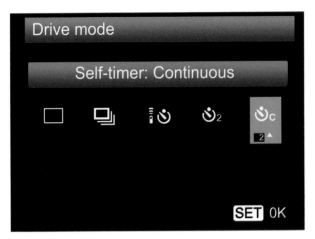

Figure 1.14
The drive modes include (left to right) Single shooting, Continuous shooting, 10-second delay/ Remote, 2-second delay, and Self-timer: Continuous (which takes multiple shots when the self-timer's delay has elapsed).

Canon recommends slipping off the eyepiece cup and replacing it with the viewfinder cap, in order to keep extraneous light from reaching the exposure meter through the viewfinder "back door." I usually just shade the viewfinder window with my hand or drape something over the back of the camera (if I plan on being in the photo myself).

Reviewing the Images You've Taken

The Canon EOS Rebel T3i has a broad range of playback and image review options, including the ability to jump ahead 10 or 100 images at a time. Here is all you really need to know, as shown in Figure 1.15:

■ **Display image.** Press the Playback button (marked with a blue right-pointing triangle just southeast of the color LCD) to display the most recent image on the LCD in full-screen Single image mode. If you last viewed your images using the thumbnail mode (described later in this list), the index display appears instead.

Change type
of information
displayed

View *View* *Zoom Out/*
previous *next* *Change* *Zoom*
image *image* *thumbnails* *In*

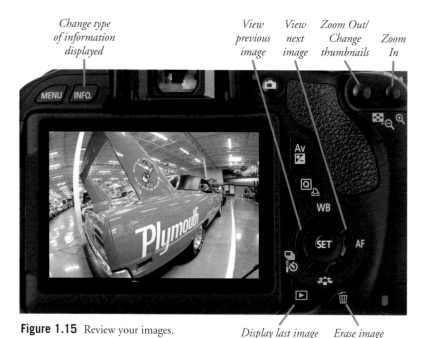

Figure 1.15 Review your images.

Display last image *Erase image*
captured/Exit *displayed*
image display *on screen*

- **View additional images.** Use the left and right cross keys to view the next or previous image.

- **View thumbnail images.** You can also rapidly move among a large number of images using the index mode described in the section that follows this list. The Reduce Image/Zoom Out button in full-frame view switches from single image to display of four or nine reduced-size thumbnails. To change from a larger number of thumbnails to a smaller number (from nine to four to single image, for example), press the Zoom In button until the display you want appears.

- **Jump ahead or back.** If you want to zip through your shots more quickly to find a specific image, rotate the Main Dial to leap ahead or back 10 or 100 images, depending on the increment you've set using the second entry in the Playback 2 menu. I find the T3i's use of the Main Dial is fast, because you don't have to fumble for the Jump button used in some earlier Canon models; just spin the dial. You can also jump ahead by screens of images, by date, or by folder.

- **View image information.** Press the INFO button repeatedly to cycle among overlays of basic image information, detailed shooting information, or no information at all.

- **Zoom in on an image.** When an image is displayed full-screen on your LCD, press the Magnify/Enlarge button repeatedly to zoom in. The Magnify/Enlarge button is located in the upper-right corner of the back of the camera, marked with a blue magnifying glass with a plus sign in it. The Reduce Image button, located to the right of the Magnify/Enlarge button, zooms back out. Press the Playback button to exit magnified display.

- **Scroll around in a magnified image.** Use the left/right/up/down cross keys to scroll around within a magnified image.

Cruising Through Index Views

As mentioned previously, you can navigate quickly among thumbnails representing a series of images using the T3i's index mode. Here are your options:

- **Display thumbnails.** Press the Playback button to display an image on the color LCD. If you last viewed your images using index mode, an index array of four or nine reduced-size images appears automatically. If an image pops up full-screen in Single image mode, press the Reduce Image button once to view four thumbnails, or twice to view nine thumbnails. You can switch between four, nine, and single images by pressing the Reduce Image button to see more/smaller versions of your images, and the Magnify/Enlarge button to see fewer/larger versions of your images.

■ **Navigate within a screen of index images.** In index mode, use the up/down/left/right cross keys to move the blue highlight box around within the current index display screen.

■ **View more index pages.** To view additional index pages, rotate the Main Dial. The display will leap ahead or back by the Jump increment you've set in the Playback 2 menu (as described in Chapter 3), 10 or 100 images, by index page, by date, or by folder.

■ **Check image.** When an image you want to examine more closely is highlighted, press the Magnify/Enlarge button until the Single image version appears full-screen on your LCD.

Using the Built-in Flash

The built-in flash is easy enough to work with that you can begin using it right away, either to provide the main lighting of a scene, or as supplementary illumination to fill in the shadows. The T3i will automatically balance the amount of light emitted from the flash so that it illuminates the shadows nicely, without overwhelming the highlights and producing a glaring "flash" look.

The flash will pop up automatically when using any of the Basic Zone modes except for Landscape, Sports, or No Flash modes. In Creative Zone modes, just press the flash button on the left side of the camera (from shooting position). When using these modes, the flash functions in the following way:

■ **P (Program mode).** The T3i selects a shutter speed from 1/60th to 1/200th second and appropriate aperture automatically.

■ **Tv (Shutter-priority mode).** You choose a shutter speed from 30 seconds to 1/200th second, and the T3i chooses the lens opening for you, while adjusting the flash output to provide the correct exposure.

■ **Av (Aperture-priority mode).** You select the aperture you want to use, and the camera will select a shutter speed from 30 seconds to 1/200th second, and adjust the flash output to provide the correct exposure. In low light levels, the T3i may select a very slow shutter speed to allow the flash and background illumination to balance out, so you should use a tripod. (You can disable this behavior using C.Fn I-3 Flash sync. speed in Av mode, as described in Chapter 4.)

■ **M (Manual mode).** You choose both shutter speed and aperture, and the camera will adjust the flash output to produce a good exposure based on the aperture you've selected.

■ **A-DEP (Automatic depth-of-field mode).** When using flash, the A-DEP setting functions exactly the same as the P (Program mode) setting.

Transferring Photos to Your Computer

You can transfer the photos you've taken to your computer for printing, further review, or image editing. Your T3i allows you to print directly to PictBridge-compatible printers and to create print orders right in the camera, plus you can select which images to transfer to your computer.

For now, you'll probably want to transfer your images either by using a cable transfer from the camera to the computer or by removing the memory card from the T3i and transferring the images with a card reader. The latter option is usually the best, because it's usually much faster and doesn't deplete the battery of your camera. However, you can use a cable transfer when you have the cable and a computer, but no card reader (perhaps you're using the computer of a friend or colleague, or at an Internet café).

To transfer images from the camera to a Mac or PC computer using the USB cable:

1. Turn off the camera.
2. Pry back the rubber cover that protects the Rebel T3i's USB port, and plug the USB cable furnished with the camera into the USB port. (See Figure 1.16.)

USB port

Figure 1.16
Images can be transferred to your computer using a USB cable plugged in to this port.

3. Connect the other end of the USB cable to a USB port on your computer.

4. Turn on the camera. Your installed software usually detects the camera and offers to transfer the pictures, or the camera appears on your desktop as a mass storage device, enabling you to drag and drop the files to your computer.

To transfer images from a memory card to the computer using a card reader:

1. Turn off the camera.

2. Slide open the memory card door, and press on the card, which causes it to pop up so it can be removed from the slot.

3. Insert the memory card into your memory card reader. Your installed software detects the files on the card and offers to transfer them. The card can also appear as a mass storage device on your desktop, which you can open, and then drag and drop the files to your computer.

Chapter 2

Canon EOS Rebel T3i Roadmap

You should find this roadmap of the functions of the T3i's controls more useful than the tiny black-and-white drawings in the manual packed with the camera, which has dozens of cross-references that send you on an information scavenger hunt through dozens of pages. Everything you need to know about the controls themselves is here. You'll find descriptions of menus and settings in Chapters 3 and 4.

Canon EOS Rebel T3i: Front View

Figure 2.1 shows a front view of the Canon T3i from a 45-degree angle. The main components you need to know about are as follows:

- **Hand grip.** This provides a comfortable hand-hold, and also contains the T3i's battery.
- **Memory card door.** Slide this panel towards the back of the camera to gain access to the memory card.

Memory DC Remote Red-eye
card access power Hand control Main Shutter reduction/Self
door port grip sensor Dial release -timer lamp Microphone

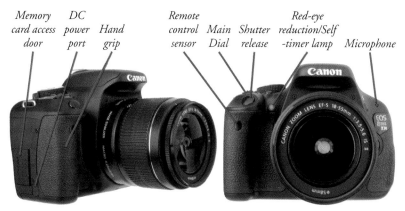

Figure 2.1

- **DC power access cover.** You'll find a connector for DC power under this small rubber door in the side of the camera.

- **Shutter release.** Angled on top of the hand grip is the shutter release button. Press this button down halfway to lock exposure and focus (in One-Shot mode and AI Focus with nonmoving subjects). The T3i assumes that when you tap or depress the shutter release, you are ready to take a picture, so the release can be tapped to activate the exposure meter or to exit from most menus.

- **Main Dial.** This dial is used to change shooting settings. When settings are available in pairs (such as shutter speed/aperture), this dial will be used to make one type of setting, such as shutter speed. The other setting, say, the aperture, is made using an alternate control, such as spinning the Main Dial while holding down an additional button like the exposure compensation button (which resides conveniently under the thumb on the back of the camera).

- **Red-eye reduction/self-timer lamp.** This LED provides a blip of light shortly before a flash exposure to cause the subjects' pupils to close down, reducing the effect of red-eye reflections off their retinas. When using the self-timer, this lamp also flashes to mark the countdown until the photo is taken.

- **Remote control sensor.** The sensor behind this window receives signals from the optional Canon RC-1, RC-5, and RC-6 infrared remote controls. The RC-1 trips the shutter immediately or after a two-second delay, while the RC-5 always initiates a two-second delay before taking the picture. The RC-6 release gives the choice of triggering the camera immediately, or with the two-second delay. Note that the sensor is on the hand grip and thus would be blocked if you happened to be holding the T3i when trying to take a picture. In practice, of course, the camera will be mounted on a tripod or supported in some other way when using the remote control. The remote control generally must be used from in front of the camera for the sensor to detect its signal.

- **Microphone.** This is a monaural (non-stereo) microphone for recording the audio track of your HDTV movies. You can plug a stereo mic into a port on the side, which I'll show you later in this chapter.

Figure 2.2 shows a front view of the Rebel T3i from the other side, with the electronic flash elevated. The controls here include:

- **Flash button.** This button releases the built-in flash so it can flip up and start the charging process. If you decide you do not want to use the flash, you can turn it off by pressing the flash head back down. Note that in some auto modes it will keep popping back up.

Figure 2.2

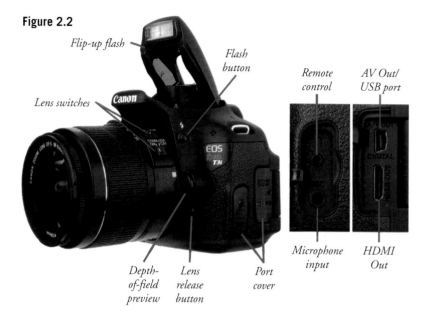

- **Lens release button.** Press and hold this button to unlock the lens so you can rotate the lens to remove it from the camera.
- **Depth-of-field preview button.** This button, adjacent to the lens mount, stops down the lens to the aperture that will be used to take the picture, so you can see in the viewfinder how much of the image is in focus. The view grows dimmer as the aperture is reduced.
- **Lens switches.** Canon autofocus lenses have a switch to allow changing between automatic focus and manual focus, and, in the case of IS lenses, another switch to turn image stabilization on and off.
- **Port covers.** Flip back these covers to reveal four input/output/control ports described next:
- **Microphone input.** Plug a stereo microphone into this jack.
- **Remote control terminal.** You can plug various Canon remote release switches, timers, and wireless controllers into this connector.
- **USB/Video out port.** Plug in the USB cable furnished with your Rebel T3i and connect the other end to a USB port in your computer to transfer photos. Or, connect the AV cable and connect your camera to a television to view your photos on a large screen.
- **HDMI port.** Use a Type C HDMI cable (not included in the box with your camera) to direct the video and audio output of the T3i to a high-definition television (HDTV) or HD monitor.

The Rebel T3i's Back Panel

The back panel of the Rebel T3i (see Figure 2.3) bristles with more than a dozen different controls, buttons, and knobs. That might seem like a lot of controls to learn, but you'll find, as I noted earlier, that it's a lot easier to press a dedicated button and spin a dial than to jump to a menu every time you want to change a setting.

You can see the controls clustered on the top edge of the T3i in Figure 2.3. The key buttons and components and their functions are as follows:

- **Viewfinder eyepiece.** You can frame your composition by peering into the viewfinder. It's surrounded by a soft rubber frame that seals out extraneous light when pressing your eye tightly up to the viewfinder, and it also protects your eyeglass lenses (if worn) from scratching.

- **MENU button.** Summons/exits the menu displayed on the rear LCD of the T3i. When you're working with submenus, this button also serves to exit a submenu and return to the main menu.

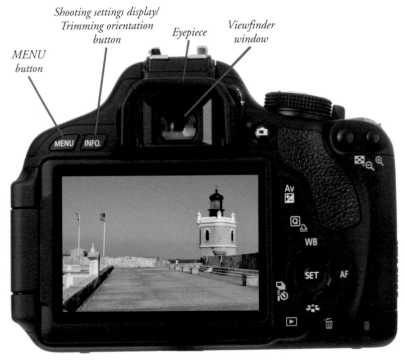

Figure 2.3

■ **INFO button.** When pressed repeatedly, changes the amount of picture information displayed. In playback mode, pressing the INFO button cycles among basic display of the image; a detailed display with a thumbnail of the image, shooting parameters, and a brightness histogram; and a display with less detail but with separate histograms for brightness, red, green, and blue channels. When setting Picture Styles, the INFO button is used to select a highlighted Picture Style for modification. In Live View mode, the INFO button adjusts the amount of information overlaid on the live image that appears on the LCD screen. When the camera is connected to a printer, you can trim an image; in direct printing mode, the INFO button selects the orientation. If you press the INFO button repeatedly, it toggles between the shooting settings screen and the camera settings screen.

■ **LCD.** This is the three-inch display that shows your Live View preview image review after the picture is taken, shooting settings display before the photo is snapped, and all the menus used by the Rebel T3i. A significant feature is the swiveling LCD, which can be folded with the display screen facing inwards to protect it or reversed into the normal position, flipped out, swiveled, or even turned around to allow you to view yourself while shooting self portraits.

INFO/DISP

On the T3i's predecessor, the button now labeled as INFO was marked DISP, and it had the same functions just outlined, plus one additional use: if you kept pressing the DISP button the cycle would eventually go to a "display off" mode. Many folks accidentally turned their display off and then wondered why they didn't have an information screen. For the T3i, Canon removed that function from this button, renamed it INFO, and placed an additional button on top of the camera (just southwest of the Main Dial, labeled DISP). This new button has one function only: turning the display on and off.

The most-used controls reside on the right side of the Rebel T3i (see Figure 2.4). There are 12 buttons in all, many of which do double-duty to perform several functions. I've divided them into two groups; here's the first:

■ **Live View/Movie button.** Press this button, marked with a red dot above it, to activate/deactivate Live View. To shoot movies, turn the Mode Dial to the Movie position, and then press this button to start/stop video/audio recording.

Figure 2.4

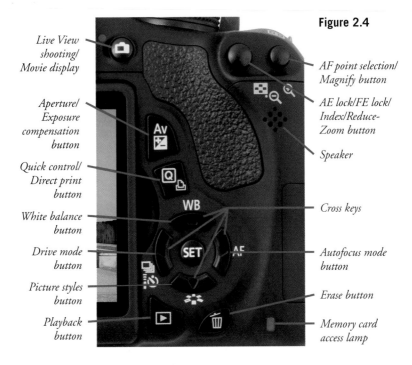

Live View shooting/ Movie display

Aperture/ Exposure compensation button

Quick control/ Direct print button

White balance button

Drive mode button

Picture styles button

Playback button

AF point selection/ Magnify button

AE lock/FE lock/ Index/Reduce- Zoom button

Speaker

Cross keys

Autofocus mode button

Erase button

Memory card access lamp

- **Cross keys.** This array of four-directional keys provides left/right/up/down movement to navigate menus, and is used to cycle among various options (usually with the left/right buttons) and to choose amounts (with the up/down buttons). The four cross keys also have secondary functions to adjust white balance, autofocus mode, Picture Styles, and drive mode.

- **SET button.** Located in the center of the cross key cluster, this button is used to confirm a selection or activate a feature.

- **Quick control/Direct print button.** This button activates the quick control screen (described later in this chapter), which allows you to set image recording quality and switch between single shot and self-timer/remote settings when using Basic Zone exposure modes, and to set a full range of controls when using Creative Zone exposure modes. The button can also be used when the T3i is connected to a printer or personal computer to initiate transfer.

- **Aperture value (AV)/Exposure compensation button.** When using manual exposure mode, hold down this button and rotate the Main Dial to specify a lens aperture; rotate the Main Dial alone to choose the shutter speed. In other Creative Zone exposure modes—Aperture-priority (Av), Shutter-

priority (Tv), or Program (P)—hold down this button and rotate the Main Dial to the right to add exposure compensation (EV) to an image (making it brighter), or rotate to the left to subtract EV and make the image darker.

■ **Playback button.** Displays the last picture taken. Thereafter, you can move back and forth among the available images by pressing the left/right cross keys to advance or reverse one image at a time, or the Main Dial, to jump forward or back using the jump method you've selected. To quit playback, press this button again. The T3i also exits playback mode automatically when you press the shutter button.

■ **Erase button.** Press to erase the image shown on the LCD. A menu will pop up displaying Cancel and Erase choices. Use the left/right cross keys to select one of these actions, then press the SET button to activate your choice.

The next group of buttons allows you to change settings:

■ **AE/FE (Auto exposure/Flash exposure) Lock/Thumbnail Index/Reduce Image button.** This button, which has a * label above it, has several func-tions, which differ depending on the AF point camera mode, and metering mode.

In Shooting mode, it locks the exposure or flash exposure that the camera sets when you partially depress the shutter button. In Evaluative exposure mode, exposure is locked at the AF point that achieved focus. In Partial, Spot, or Center-weighted modes, exposure is locked at the AF center point. The exposure lock indication (*) appears in the viewfinder and on the shoot-ing settings display. If you want to recalculate exposure with the shutter but-ton still partially depressed, press the * button again. The exposure will be unlocked when you release the shutter button or take the picture. To retain the exposure lock for subsequent photos, keep the * button pressed while shooting.

When using flash, pressing the * button fires an extra pre-flash that allows the unit to calculate and lock exposure prior to taking the picture. The char-acters FEL will appear momentarily in the viewfinder, and the exposure lock indication and a flash indicator appear. (See the description of the viewfinder display later in this chapter.)

In Playback mode, press this button to switch from single-image display to nine-image thumbnail index. (See Figure 2.5.) Move highlighting among the thumbnails with the cross keys or Main Dial. To view a highlighted image, press the Magnify/Enlarge button.

In Playback mode, when an image is zoomed in, press this button to zoom out.

Figure 2.5

The Thumbnail/ Index/Reduce Image button changes the play- back display from single image to four or nine thumbnails.

- **AF point selection/Magnify/Enlarge button.** In Shooting mode, this but- ton activates autofocus point selection. In Playback mode, if you're viewing a single image, this button zooms in on the image that's displayed. If thumb- nail indexes are shown, pressing this button switches from nine thumbnails to four thumbnails, or from four thumbnails to a full screen view of a high- lighted image.
- **White balance.** The up cross key also serves to access the white balance function. Press this WB button when using one of the Creative Zone modes (A-DEP, M, Av, Tv, or P) to produce the white balance screen. Then, use the left/right cross keys to select a white balance, and press SET to confirm.
- **AF mode.** Press the right cross key to produce a screen that allows choos- ing Autofocus mode from among One-Shot, AI Focus, and AI Servo. Press repeatedly until the focus mode you want is selected. Then press SET to confirm your focus mode.
- **Drive mode.** Press the left cross key to produce a screen that allows choos- ing a drive mode. Then press the right cross key to select the 10-second self- timer (which also can be used with the optional IR remote controls), 2-second self-timer, or Self-timer: Continuous, which allows you to spec- ify a number of shots to be taken (from 2 to 10) with the up/down keys. Press SET to confirm your choice.
- **Picture Styles selection button.** When in Shooting mode, press the down cross key to pop up the Picture Styles menu on the LCD, so you can select a given style, or gain access to user-defined styles. To modify a Picture Style, you'll need to press the down cross key to select a style, or use the Shooting

2 menu, as described in Chapter 3. When you're reviewing an image, the down cross key also cycles through the various jump options.

- **SET button.** Selects a highlighted setting or menu option.
- **Memory card access lamp.** When lit or blinking, this lamp indicates that the memory card is being accessed.

Jumping Around

When a photo you've taken is displayed on the color LCD, you can change the method used to jump with the Main Dial. To select a jump method, press the Q button and choose Jump Method. An overlay appears that allows you to choose the method. (See Figure 2.6.) Keep pressing the up key until the method you want to use is shown, then press SET to confirm your choice.

You can also choose a jump method using the Playback 2 menu (using the procedure described with all the other menus in Chapter 3). The advantage of using the menu is that you can set both the number of images to jump and the type of jump. The jump feature allows you to leap forward and backward among the images on your memory card using the increment/method you have chosen by rotating the Main Dial. The jump method is shown briefly on the screen as you leap ahead to the next image displayed. Your options are as follows:

- **1 image.** Rotating the Main Dial one click jumps forward or back one image.
- **10 images.** Rotating the Main Dial one click jumps forward or back ten images.

Figure 2.6
Choose a jump method by pressing the up cross key while viewing an image.

- **100 images.** Rotating the Main Dial one click jumps forward or back one hundred images.
- **Date.** Rotating the Main Dial one click jumps forward or back to the first image taken on the next or previous calendar date.
- **Folder.** Rotating the Main Dial one click jumps to the next folder on your memory card.
- **Display Movies only.** Tells the T3i to jump only among movie images when using a card that contains both video clips and still images. This option is useful when you prefer to view only one kind of file.
- **Display Stills only.** Specifies jumping only between still images when using a card that has both video clips and still images.
- **Display by image rating.** You can rate a particular movie or still photo by applying from one to five stars, using the Rating menu entry in the Playback 2 menu. This jump choice allows you to select a rating rank, and then jump among photos with that rating applied.

Going Topside

The top surface of the Canon EOS Rebel T3i has a few frequently accessed controls of its own. The key controls, shown in Figure 2.7, are as follows:

- **Mode Dial.** Rotate this dial to switch among Basic Zone and Creative Zone modes, described in Chapter 1.
- **Sensor focal plane.** Precision macro and scientific photography sometimes requires knowing exactly where the focal plane of the sensor is. The symbol on the side of the pentaprism marks that plane.
- **Flash hot shoe.** Slide an electronic flash into this mount when you need a more powerful Speedlite. A dedicated flash unit, like those from Canon, can use the multiple contact points shown to communicate exposure, zoom setting, white balance information, and other data between the flash and the camera. There's more on using electronic flash in Chapter 5.
- **ISO.** Press this button (just aft of the Main Dial) and use the cross keys to navigate until the setting you want appears on the LCD. Press the SET button to confirm your choice. You'll find more about ISO options in Chapter 3, and flash EV settings in Chapter 5.
- **Main Dial.** This dial is used to make many shooting settings. When settings come in pairs (such as shutter speed/aperture in Manual shooting mode), the Main Dial is used for one (for example, shutter speed), while some other control, such as the AV button (when shooting in Manual exposure mode) is used for the other (aperture).

Figure 2.7

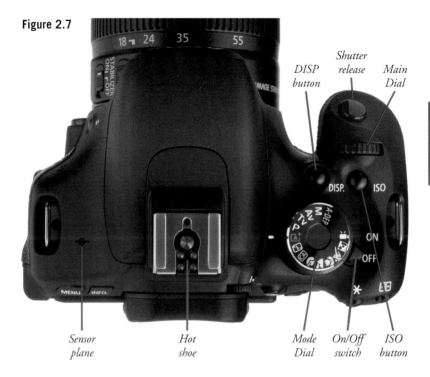

■ **Shutter release button.** Partially depress this button to lock in exposure and focus. Press all the way to take the picture. Tapping the shutter release when the camera has turned off the autoexposure and autofocus mechanisms reactivates both. When a review image is displayed on the back-panel color LCD, tapping this button removes the image from the display and reactivates the autoexposure and autofocus mechanisms.

■ **On/Off switch.** Flip forward to turn the Rebel T3i on, and back to turn it off again.

Underneath Your Rebel T3i

There's not a lot going on with the bottom panel of your Rebel T3i. You'll find a tripod socket, which secures the camera to a tripod, and is also used to lock on the optional BG-E8 battery grip, which provides more juice to run your camera to take more exposures with a single charge. It also adds a vertically oriented shutter release, Main Dial, AE lock/FE lock, and AF point selection controls for easier vertical shooting. To mount the grip, slide the battery door latch to open the door, then push gently towards the outside edge of the camera to free the

hinge pins from their sockets. That will let you remove the battery door. Then slide the grip into the battery cavity, aligning the pin on the grip with the small hole on the other side of the tripod socket. Tighten the grip's tripod socket screw to lock the grip onto the bottom of your T3i.

Lens Components

The typical lens, like the ones shown in Figure 2.8, has seven or eight common features. Not every component appears on every lens. The 18-55mm lens on the left, for example, lacks the distance scale and distance indicator that the 17-85mm lens on the right has. Lenses that lack image stabilization will not have a stabilization switch.

■ **Filter thread.** Lenses have a thread on the front for attaching filters and other add-ons. Some also use this thread for attaching a lens hood (if you want to use a filter, you screw on the filter first, and then attach the hood to the screw thread on the front of the filter).

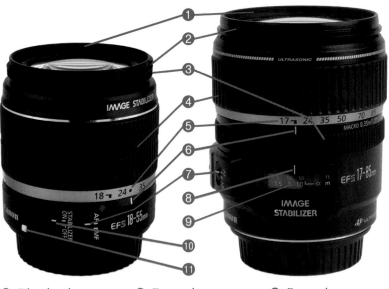

❶ *Filter threads*

❷ *Lens hood bayonet*

❸ *Focus ring*

❹ *Zoom ring*

❺ *Zoom scale*

❻ *Zoom position*

❼ *Autofocus/Manual focus switch*

❽ *Focus distance*

❾ *Focus scale*

❿ *Image stabilizer switch*

⓫ *Lens mounting index mark*

Figure 2.8

- **Lens hood bayonet.** This is used to mount the lens hood for lenses that don't use screw-mount hoods (the majority).

- **Zoom ring.** Turn this ring to change the zoom setting.

- **Zoom scale.** These markings on the lens show the current focal length selected.

- **Focus ring.** This is the ring you turn when you manually focus the lens.

- **Distance scale.** This is a readout that rotates in unison with the lens's focus mechanism to show the distance at which the lens has been focused. It's a useful indicator for double-checking autofocus, roughly evaluating depth-of-field, and for setting manual focus guesstimates.

- **Autofocus/Manual switch.** Allows you to change from automatic focus to manual focus.

- **Image stabilization switch.** Lenses with IS include a separate switch for adjusting the stabilization feature.

- **Electrical contacts.** On the back of the lens (not shown in the figure) are electrical contacts that the camera uses to communicate focus, aperture setting, and other information.

- **Lens bayonet.** This mount is used to attach the lens to a matching bayonet on the camera body.

LCD Panel Readouts

The Rebel T3i uses the generously expansive three-inch color LCD to show you everything you need to see, from images to a collection of informational data displays. Here's an overview of these displays, and how to access them:

- **Image playback displays.** When the T3i shows you a picture for review, you can select from among four different information overlays. To switch among them, press the INFO button while the image is on the screen. The LCD will cycle among the single-image display (Figure 2.9, left); single-image display with recording quality (Figure 2.9, right); histogram display, which shows basic shooting information as well as a brightness histogram at bottom right, with individual histograms for the red, green, and blue channels above (Figure 2.10, left); and a complete shooting information display (Figure 2.10, right), which includes most of the relevant shooting settings, plus a brightness histogram. I'll explain how to work with histograms in Chapter 3.

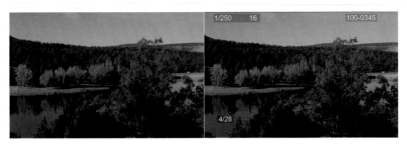

Figure 2.9 Image playback displays include single image, single image with recording quality...

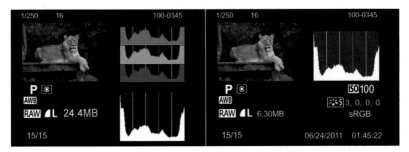

Figure 2.10 ...histogram, and shooting information.

- **Shooting settings display.** While you are taking pictures, this screen will be shown, with information like that in Figure 2.11. Not all of the data pictured will be seen at one time; only the settings that are appropriate for the current shooting mode will be displayed. You can turn this display off by pressing the DISP button, and restore it again by pressing the DISP button a second time. When the shooting settings display is active, you can return to it when there is a menu screen or image review on the LCD by tapping the shutter release button. If you want to make adjustments, press the quick control button to activate the quick control screen, and use the cross keys to navigate to the setting you want to change. As I mentioned in Chapter 1, when using Basic Zone modes other than Creative Auto, you can change only the drive mode and image quality. When using Creative Auto, you can adjust additional settings, such as flash modes, Picture Styles (or image effects), brightness, and depth-of-field (range of sharpness). With Creative Zone modes, you can change any of the settings visible in the quick control screen.

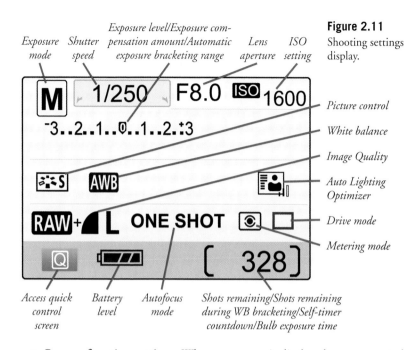

Exposure level/Exposure compensation amount/Automatic exposure bracketing range

Exposure mode Shutter speed Lens aperture ISO setting

Figure 2.11
Shooting settings display.

Picture control

White balance

Image Quality

Auto Lighting Optimizer

Drive mode

Metering mode

Access quick control screen Battery level Autofocus mode Shots remaining/Shots remaining during WB bracketing/Self-timer countdown/Bulb exposure time

■ **Camera function settings.** When any menu is displayed, you can switch to the camera functions settings screen by pressing the INFO button. (You may need to press the DISP button, which turns the display on and off, first.) A screen like the one shown in Figure 2.12 will appear, with key camera function settings arrayed.

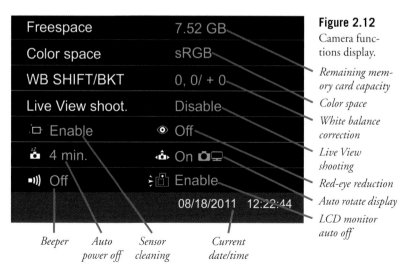

Figure 2.12
Camera functions display.

Remaining memory card capacity

Color space

White balance correction

Live View shooting

Red-eye reduction

Auto rotate display

LCD monitor auto off

Beeper Auto power off Sensor cleaning Current date/time

Looking Inside the Viewfinder

Much of the important shooting status information is shown inside the viewfinder of the Rebel T3i. As with the displays shown on the color LCD, not all of this information will be shown at any one time. Figure 2.13 shows what you can expect to see. These readouts include the following:

- **Spot metering reference circle.** Shows the circle that delineates the metered area when Spot metering is activated. (The reference circle is visible at all times, even when you're not using Spot metering.)

- **Autofocus zones.** Shows the nine areas used by the T3i to focus. The camera can select the appropriate focus zone for you, or you can manually select one or all of the zones, as described in Chapter 1.

- **Autoexposure lock.** Shows that exposure has been locked. This icon also appears when an automatic exposure bracketing sequence is in process.

- **Flash-ready indicator.** This icon appears when the flash is fully charged. It also shows when the flash exposure lock has been applied for an inappropriate exposure value.

- **Flash status indicator.** Appears along with the flash-ready indicator: The H is shown when high-speed (focal plane) flash sync is being used (with an external flash). The * appears when flash exposure lock or a flash exposure bracketing sequence is underway.

- **Flash exposure compensation.** Appears when flash EV changes have been made.

- **Shutter speed/aperture readouts.** Most of the time, these readouts show the current shutter speed and aperture. This pair can also warn you of memory card conditions (full, error, or missing), ISO speed, flash exposure lock, and a buSY indicator when the camera is busy doing other things (including flash recycling).

- **Exposure level indicator.** This scale shows the current exposure level, with the bottom indicator centered when the exposure is correct as metered. The indicator may also move to the left or right to indicate under- or overexposure (respectively). The scale is also used to show the amount of EV and flash EV adjustments, the number of stops covered by the current automatic exposure bracketing range, and is used as a red-eye reduction lamp indicator.

- **ISO sensitivity.** This useful indicator shows the current ISO setting value. Those who have accidentally taken dozens of shots under bright sunlight at ISO 1600 because they forgot to change the setting back after some indoor shooting will treasure this addition.

■ **B/W indicator.** Illuminates when the Monochrome Picture Style is being used. There's no way to restore color when you're shooting JPEGs without RAW, so this indicator is another valuable warning.

■ **White balance correction.** Shows that white balance has been tweaked.

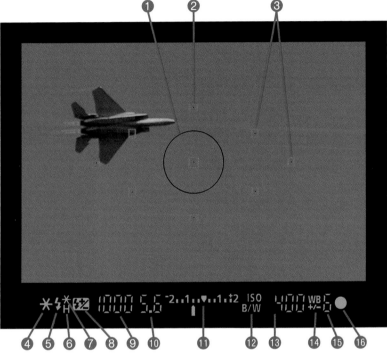

❶ Spot metering circle	❽ Flash exposure compensation	❿ Black-and-white shooting
❷ AF point display indicator	❾ Shutter speed/Card full warning	⓭ ISO speed
❸ AF points	❿ Aperture	⓮ White balance correction
❹ AE lock/Automatic exposure bracketing in progress	⓫ Exposure level indicator/ Exposure compensation amount/Autoexposure bracketing range/Red-eye reduction lamp on indicator	⓯ Maximum burst
❺ Flash-ready/Improper FE lock warning		⓰ Focus confirmation
❻ High-speed sync		
❼ FE lock/Flash exposure bracketing in progress		

Figure 2.13

- **Maximum burst available.** Changes to a number to indicate the number of frames that can be taken in Continuous mode using the current settings.
- **Focus confirmation.** This green dot appears when the subject covered by the active autofocus zone is in sharp focus.

Chapter 3

Shooting and Playback Menu Settings

The Shooting and Playback menus determine how the T3i uses many of its shooting features to take a photo, and how it displays images on review. You'll find the Set-up and My Menu settings in Chapter 4. Two of the three Movie shooting menus are described in Chapter 6. (The third menu duplicates some of the Shooting menu entries discussed in this chapter.)

Anatomy of the Canon EOS T3i's Menus

Press the MENU button on the upper-left edge of the camera to access the menu system. The most recently accessed menu will appear, as in Figure 3.1. When you're using any Mode Dial option other than Scene Intelligent Auto and Creative Auto, there are 10 menu tabs: Shooting 1, Shooting 2, Shooting 3, Shooting 4, Playback 1, Playback 2, Set-up 1, Set-up 2, Set-up 3, and My Menu.

In Scene Intelligent Auto and Creative Auto there are only six tabs: Shooting 1, 2; Playback 1, 2; and Set-up 1, 2. The Shooting 3, Shooting 4, Set-up 3, Set-up 4, and My Menu choices are not available, and the options within the menus are slightly different. When the Mode Dial is set to Movie mode, there are three Movie menus, one Shooting menu, two Playback menus, and two Set-up menus. In this chapter, I'm going to explain all the tabs and all the menu entries for still shooting. The Movie menus will be discussed in Chapter 6 and won't be repeated here.

The T3i's tabs are color-coded: red for Shooting menus, blue for Playback menus, amber for Set-up menus, and green for the My Menu tab. The currently selected menu's icon is white within a white border, on a background corresponding to its color code. All the inactive menus are dimmed and the icon and their borders are color-coded.

- **Menu tabs.** In the top row of the menu screen, the menu that is currently active will be highlighted as described earlier. One, two, or three dots in the tab lets you know if you are in, say Set-up 1, Set-up 2, or Set-up 3. Just remember that the three red camera icons stand for shooting options; the two blue right-pointing triangles represent playback options; the three yellow wrench icons stand for set-up options; and the green star stands for personalized menus defined for the star of the show—you.

- **Selected menu item.** The currently selected menu item will have white text/icons on a black background and will be surrounded by a box the same hue as its color code.

- **Other menu choices.** The other menu items visible on the screen will have a dark gray background.

- **Current setting.** The current settings for visible menu items are shown in the right-hand column, until one menu item is selected (by pressing the SET button). At that point, all the settings vanish from the screen except for those dealing with the active menu choice.

When you've moved the menu highlighting with the up/down cross keys to the menu item you want to work with, press the SET button to select it. A submenu with a list of options for the selected menu item will appear. Within the submenu options, you can scroll up or down with the up/down cross keys to choose a setting, and then press SET to confirm the choice you've made. Press the MENU button again or tap the shutter release button to exit.

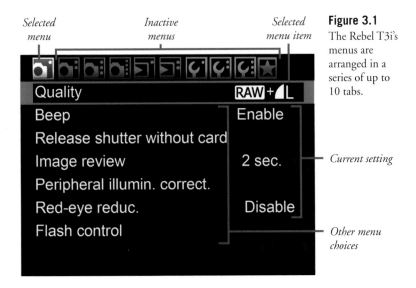

Selected menu *Inactive menus* *Selected menu item*

Figure 3.1
The Rebel T3i's menus are arranged in a series of up to 10 tabs.

Current setting

Other menu choices

Shooting 1, 2, and 3 Menu Options

The options you'll find in the red-coded Shooting menus include the following:

- Quality
- Beep
- Release shutter without card
- Image review
- Peripheral illumination correction
- Red-eye reduction
- Flash control
- Exposure compensation/ AEB (Automatic Exposure Bracketing)
- Auto Lighting Optimizer
- Metering mode

- Custom White Balance
- WB Shift/BKT
- Color Space
- Picture Style
- Dust Delete Data
- ISO Auto
- Live View shooting
- AF mode
- Grid display
- Aspect ratio
- Metering timer

Quality Settings

Options: Resolution, JPEG compression, JPEG, RAW, or both

You can choose the image quality settings used by the T3i to store its files. You have three choices to make:

- **Resolution.** The number of pixels captured determines the absolute resolution of the photos you shoot with your T3i. Your choices range from 18 megapixels (Large or L), measuring 5184 × 3456; 8 megapixels (Medium or M), measuring 3456 × 2304 pixels; 4.5 megapixels (Small 1 or S1), 2592 × 1728 pixels; 2.5 megapixels (Small 2 or S2), 1920 × 1280; and 350,000 pixels (Small 3 or S3), 720 × 480.

- **JPEG compression.** To reduce the size of your image files and allow more photos to be stored on a given memory card, the T3i uses JPEG compression to squeeze the images down to a smaller size. This compacting reduces the image quality a little, so you're offered your choice of Fine compression and Normal compression. The symbols help you remember that Fine compression (represented by a quarter-circle) provides the smoothest results, while Normal compression (signified by a stair-step icon) provides "jaggier" images.

■ **JPEG, RAW, or both.** You can elect to store only JPEG versions of the images you shoot (6.4MB each at the Large Fine resolution setting) or you can save your photos as uncompressed, loss-free RAW files, which consume about four times as much space on your memory card (up to 20MB per file). Or, you can store both at once as you shoot. Many photographers elect to save *both* a JPEG and a RAW file, so they'll have a JPEG version that might be usable as-is, as well as the original "digital negative" RAW file in case they want to do some processing of the image later. You'll end up with two different versions of the same file: one with a JPG extension, and one with the CR2 extension that signifies a Canon RAW file.

To choose the combination you want, access the menus, scroll to Quality, and press the SET button. Use the cross keys to cycle among the choices. In practice, you'll probably use only the Large (Fine), RAW+L (Large Fine), or RAW selections if you want the best quality images.

Beep

Options: Enable, Disable

The Rebel T3i's internal beeper provides a helpful chirp to signify various functions, such as the countdown of your camera's self-timer. You can switch it off if you want to avoid the beep because it's annoying, impolite, or distracting (at a concert or museum), or undesired for any other reason.

Release Shutter without Card

Options: Enable, Disable

This entry in the Shooting 1 menu gives you the ability to snap off "pictures" without a memory card installed—or to lock the camera shutter release if that is the case. When using the "demo" mode, the message "No Card in Camera" appears overlaid on the review image on the LCD.

Image Review

Options: Off, 2 sec., 4 sec., 8 sec., Hold

You can adjust the amount of time an image is displayed for review on the LCD after each shot is taken. You can elect to disable this review entirely (Off), or choose display times of 2 sec., 4 sec., or 8 sec.. You can also select Hold, an indefinite display, which will keep your image on the screen until you use one of the other controls, such as the shutter button or Main Dial. Turning the review display off or choosing a brief duration can help preserve battery power. However,

the T3i will always override the review display when the shutter button is partially or fully depressed, so you'll never miss a shot because a previous image was on the screen.

Peripheral Illumination Correction

Options: Enable, Disable

With certain lenses, under certain conditions, your images might suffer from a phenomenon called *vignetting*, which is a darkening of the four corners of the frame because of a slight amount of fall-off in illumination at those nether regions. This menu option allows you to activate a clever feature built into the EOS T3i that partially (or fully) compensates for this effect. Depending on the f/stop you use, the lens mounted on the camera, and the focal length setting, vignetting can be non-existent, slight, or may be so strong that it appears you've used a too-small hood on your camera. (Indeed, the wrong lens hood can produce a vignette effect of its own.) Vignetting can be affected by the use of a telephoto converter.

Peripheral illumination drop-off, even if pronounced, may not be much of a problem. I actually *add* vignetting, sometimes, when shooting portraits and some other subjects. Slightly dark corners tend to focus attention on a subject in the middle of the frame. On the other hand, vignetting with subjects that are supposed to be evenly illuminated, such as landscapes, is seldom a benefit.

When you select this menu option from the Shooting 1 menu, the lens currently attached to the camera is shown, along with a notation whether correction data needed to brighten the corners is already registered in the camera. (Information about 20 of the most popular lenses is included in the T3i's firmware.) (See Figure 3.2.) If so, you can select Enable to activate the feature, or Disable to turn it off. Press the SET button to confirm your choice. Note that in-camera correction must be applied *before* you take the photo.

If your lens is not registered in the camera, you can remedy that deficit using the EOS Utility. Just follow these steps.

1. Connect your T3i to your computer using the USB cable supplied with the camera.

2. Load the EOS Utility and click on Camera Settings/Remote Shooting from the splash screen that appears.

3. Choose the Shooting menu from the menu bar located about midway in the control panel that appears on your computer display.

4. Click on the Peripheral illumin. correct. choice.

5. Select the category containing the lens you want to register from the panels at the top of the new screen, then place a check mark next to all the lenses you'd like to register in the camera.

6. Click OK to send the data from your computer to the T3i and register your lenses.

7. When a newly registered lens is mounted on the camera, you will be able to activate the anti-vignetting feature for that lens from the Shooting 1 menu, as shown in Figure 3.2.

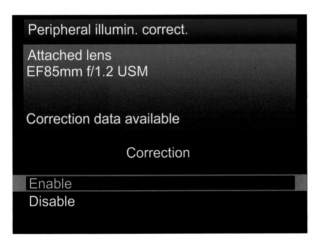

Figure 3.2
Select the lenses to be corrected.

Red-Eye Reduction

Options: Disable, Enable

Although your Rebel T3i has a fairly effective red-eye reduction flash mode, it is unable, on its own, to totally *eliminate* the red-eye effects that occur when an electronic flash (or, rarely, illumination from other sources) bounces off the retinas of the eye and into the camera lens. Animals seem to suffer from yellow or green glowing pupils, instead; the effect is equally undesirable. The effect is worst under low-light conditions (exactly when you might be using a flash) as the pupils expand to allow more light to reach the retinas. The best you can hope for is to *reduce* or minimize the red-eye effect.

The best way to truly eliminate red-eye is to raise the flash up off the camera so its illumination approaches the eye from an angle that won't reflect directly back to the retina and into the lens. The extra height of the built-in flash may not be sufficient, however. If you're working with your T3i's built-in flash, your only recourse may be to switch to the Red-eye reduction feature menu choice. It

causes a lamp on the front of the camera to illuminate with a half-press of the shutter release button, which may cause your subjects' pupils to contract, decreasing the amount of the red-eye effect. You may have to ask your subject to look at the lamp to gain maximum effect.

Flash Control

Options: Flash firing, E-TTL II metering, Built-in flash function, External flash function, External flash C. Fn. Setting, Clear external flash C. Fn. Setting

This multi-level menu entry includes six settings for controlling the Canon EOS Rebel T3i's built-in, pop-up electronic flash unit, as well as accessory flash units you can attach to the camera (see Figure 3.3). Here are your main options.

Flash Firing

Use this option to enable or disable the built-in electronic flash. You might want to totally disable the T3i's flash (both built-in and accessory flash) when shooting in sensitive environments, such as concerts, in museums, or during religious ceremonies. When disabled, the flash cannot fire even if you accidentally elevate it, or have an accessory flash attached and turned on. If you turn off the flash here, it is disabled in any exposure mode.

E-TTL II Metering

You can choose Evaluative (matrix) or Average metering modes for the electronic flash exposure meter. Evaluative looks at selected areas in the scene to calculate exposure, while Average calculates flash exposure by reading the entire scene.

Figure 3.3
The Flash control menu entry has five setting submenus.

Built-in Flash Function Setting

There are a total of seven choices for this menu screen (one of the few that is long enough to require a scroll bar). The additional options are grayed out unless you're working in wireless flash mode.

■ **Built-in flash.** Your choices here are Normal Firing, Easy Wireless, and Custom Wireless. The first choice is used when you're working with the built-in flash only; the two other options are used when you are syncing your camera with a wireless external flash.

■ **Flash Mode.** This entry is available only if you've selected Custom Wireless (above), and allows you to choose from automatic exposure calculation (E-TTL II) or manual flash exposure.

■ **Shutter sync.** Available only in Normal Firing mode, you can choose 1st curtain sync, which fires the pre-flash used to calculate the exposure before the shutter opens, followed by the main flash as soon as the shutter is completely open. This is the default mode, and you'll generally perceive the pre-flash and main flash as a single burst. Alternatively, you can select 2nd curtain sync, which fires the pre-flash as soon as the shutter opens, and then triggers the main flash in a second burst at the end of the exposure, just before the shutter starts to close. (If the shutter speed is slow enough, you may clearly see both the pre-flash and main flash as separate bursts of light.) This action allows photographing a blurred trail of light of moving objects with sharp flash exposures at the beginning and the end of the exposure. This type of flash exposure is slightly different from what some other cameras produce using 2nd curtain sync.

If you have an external compatible Speedlite attached, you can also choose Hi-speed sync, which allows you to use shutter speeds faster than 1/200th second, using the External Flash Function Setting menu, described next and explained in Chapter 5.

■ **Flash exposure compensation.** If you'd rather adjust flash exposure using a menu than with the ISO/Flash exposure compensation button, you can do that here. Select this option with the SET button, then dial in the amount of flash EV compensation you want using the cross keys. The EV that was in place before you started to make your adjustment is shown as a blue indicator, so you can return to that value quickly. Press SET again to confirm your change, then press the MENU button twice to exit.

- **Wireless functions.** These choices appear when you've selected Custom Wireless, and include mode, channel, firing group, and other options that are used only when you're working in wireless mode to control an external flash. If you've disabled wireless functions, the other options don't appear on the menu.

- **Clear flash settings.** When the Built-in flash func. setting (or External flash func. setting) screen is shown, you can press the INFO button to produce a screen that allows you to clear all the flash settings.

External Flash Function Setting

You can access this menu only when you have a compatible electronic flash attached and switched on. The settings available are shown in Figure 3.4. If you press the INFO button while adjusting flash settings, both the changes made to the settings of an attached external flash and to the built-in flash will be cleared.

- **Flash mode.** This entry allows you to set the flash mode for the external flash, from E-TTL II, Manual flash, MULTI flash, TTL, AutoExtFlash, or Man.Ext flash. The first three are identical to the built-in flash modes described earlier. The second three are optional metering modes available with certain flash units, such as the 580 EX II, and are provided for those who might need one of those less sophisticated flash metering systems. While I don't recommend any of the latter three, you can find more information about them in your flash's manual.

- **Shutter sync.** As with the T3i's built-in flash, you can choose 1st curtain sync, which fires the flash as soon as the shutter is completely open (this is the default mode). Alternatively, you can select 2nd curtain sync, which fires the flash as soon as the shutter opens, and then triggers a second flash at the end of the exposure, just before the shutter starts to close.

Figure 3.4
External flash units can be controlled from the Canon EOS Rebel T3i using this menu.

- **FEB.** Flash Exposure Bracketing (FEB) operates similarly to ordinary exposure bracketing, providing a series of different exposures to improve your chances of getting the exact right exposure, or to provide alternative renditions for creative purposes.

- **Zoom.** Some flash units can vary their coverage to better match the field of view of your lens at a particular focal length. You can allow the external flash to zoom automatically, based on information provided, or manually, using a zoom button on the flash itself. This setting is disabled when using a flash like the Canon 270EX II, which does not have zooming capability.

- **Wireless functions.** You can enable or disable the use of the external flash in wireless mode.

- **Master flash.** Enable or disable the external flash as a master that controls other flash units wirelessly.

- **Channel.** When wireless functions are enabled, you can select one of four channels the external flash uses to communicate with the other flash units.

- **Firing group.** Each flash can be assigned to one of three groups, labeled A, B, and C. This entry controls which channels are addressed.

- **Flash exposure compensation.** You can adjust flash exposure using a menu here. Select this option with the SET button, then dial in the amount of flash EV compensation you want using the cross keys. The EV that was in place before you started to make your adjustment is shown as a blue indicator, so you can return to that value quickly. Press SET again to confirm your change, then press the MENU button twice to exit.

- **A:B fire ratio.** Here you can set the relative proportion of light contributed by firing Groups A and B.

- **Group C exposure compensation.** You can set exposure compensation values separately for flashes assigned to Group C.

External Flash Custom Function Setting

Many external Speedlites from Canon include their own list of Custom Functions, which can be used to specify things like flash metering mode and flash bracketing sequences, as well as more sophisticated features, such as modeling light/flash (if available), use of external power sources (if attached), and functions of any slave unit attached to the external flash. This menu entry allows you to set an external flash unit's Custom Functions from your T3i's menu.

Clear External Flash Custom Function Setting

This entry allows you to zero-out any changes you've made to your external flash's Custom Functions, and return them to their factory default settings.

Exposure Compensation/Automatic Exposure Bracketing

Options: 1/3 stop increments, plus/minus stops

This is the first menu entry in the Shooting 2 menu. (See Figure 3.5.) To use this option, just select Exposure comp./AEB, press SET, and then:

- **Add or subtract exposure compensation.** When the screen shown in Figure 3.6 is visible, press the left/right cross keys to subtract or add exposure. You can bypass the menu entirely when the shooting settings screen is visible by pressing the Av button (to the right of the LCD) and rotating the Main Dial.

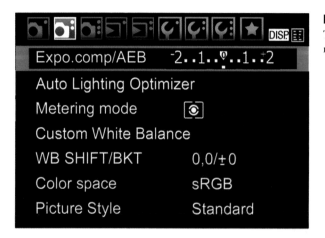

Figure 3.5
The Shooting 2 menu.

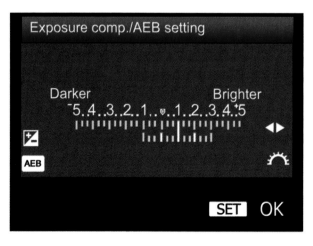

Figure 3.6
Add or subtract exposure compensation, or set the range of the three bracketed exposures.

■ **Activate exposure bracketing.** When the screen is visible, rotate the Main Dial to spread the three blocks representing the bracketed exposures by the size of the bracket increment you want. Then, optionally, use the left/right cross keys to shift the bracket so the center exposure is less or more than the base exposure calculated by the camera.

As you take pictures, the amount of bracketing will be shown as three indicators in the analog exposure display that flash when the shutter release button is pressed halfway. When AEB is activated, the three bracketed shots will be exposed in this sequence: metered exposure, decreased exposure, increased exposure. To cancel bracketing, select this menu option again, and use the left cross key to converge all the bracket indicators once more.

Auto Lighting Optimizer

Options: Disable, Low, Standard, Strong

Auto Lighting Optimizer provides a partial fix for JPEG images that are too dark or flat. The Auto Lighting Optimizer improves them—as you shoot—by increasing both the brightness and contrast as required. The feature is used automatically at the Standard setting in Basic Zone modes, but can be activated here for Creative Zone modes, Program, Aperture-priority, and Shutter-priority modes (but not Manual mode). You can select from four settings: Standard (the default value), Low, Strong, and Disable. I prefer to leave it set on Disable most of the time, and use Standard mode when I see that a particular scene is coming out too dark when I review the photos on the LCD. If that doesn't help, I may shift into Strong mode—but still take a few shots with the feature disabled in case I decide back at my computer screen that my lighting hasn't actually been "optimized."

Metering Mode

Options: Evaluative, Partial, Spot, Center-weighted averaging

Use this menu option to switch among Evaluative, Partial, Spot, and Center-weighted average metering.

Custom White Balance

Options: Manually set white balance

Pressing the WB button (the up cross key) allows you to choose Automatic white balance or one of the six preset settings (Daylight, Shade, Cloudy, Tungsten, White Fluorescent, or Flash), suitable for a variety of lighting conditions, using the cross keys or Main Dial. If none of them are suitable, you can set a Custom white balance using this menu option. The custom setting you establish will then be applied whenever you select Custom using the WB button.

To set the white balance to an appropriate color temperature under the current ambient lighting conditions, follow these steps.

1. Focus manually (with the lens set on MF) on a plain white or gray object, such as a card or wall, making sure the object fills the spot metering circle in the center of the viewfinder.

2. Take a photo.

3. Press the MENU button and select Custom White Balance from the Shooting 2 menu.

4. The reference image you just took appears. If you want to use a different picture, use the left/right cross keys to navigate to the photo you'd like to use.

5. Press the SET button to store the white balance of the image as your custom setting.

6. If the selected image can be used to record white balance, a message will appear: Use WB data from this image for Custom WB. You can select Cancel or OK.

 If the T3i can't use the image you select, a different message appears: Correct WB may not be obtained with the selected image. In that case, choose a different photo or go back to Step 1.

7. Once you've stored an image's white balance, henceforth, you can access this customized setting by pressing the WB button and choosing the custom icon. It's the one at the extreme right of the screen that pops up.

White Balance Shift and Bracketing

Options: White balance correction, White balance bracketing

White balance shift allows you to dial in a white balance color bias along the blue/amber (yellow) dimensions, and/or magenta/green scale. In other words, you can set your color balance so that it is a little bluer or yellower (only), a little more magenta or green (only), or a combination of the two bias dimensions. You can also bracket exposures, taking several consecutive pictures each with a slightly different color balance biased in the directions you specify.

The process is a little easier to visualize if you look at Figure 3.7. The center intersection of lines BA and GM (remember high school geometry!) is the point of zero bias. Move the point at that intersection using the left/right and up/down cross keys to locate it at any point on the graph using the blue/amber (yellow) and green/magenta coordinates. The amount of shift will be displayed in the SHIFT box to the right of the graph.

White balance bracketing is like white balance shifting, only the bracketed changes occur along the bias axis you specify. The three squares in Figure 3.7

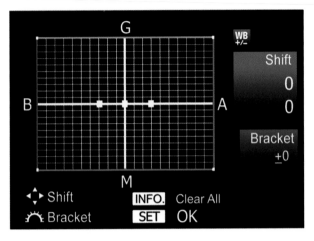

Figure 3.7
Use the Main Dial to specify color balance bracketing using green/magenta bias or to specify blue/amber (yellow) bias. The up/down and left/right cross keys can be used to maneuver the bracketing into any quadrant.

show that the white balance bracketing will occur in two stop steps along the blue/amber (yellow) axis. The amount of the bracketing is shown in the lower box to the right of the graph.

This form of bracketing is similar to exposure bracketing, but with the added dimension of hue instead of brightness/darkness. Bias bracketing can be performed in any JPEG-only mode. You can't use RAW or RAW+JPEG, because the RAW files already contain the information needed to fine-tune the white balance and white balance bias.

White Balance Bracketing
Follow these steps to bracket white balance.

1. **Activate white balance shift/bracketing.** Select WB SHIFT/BKT from the Shooting 2 menu.

2. **Choose the amount of the WB bracketing.** Rotate the Main Dial to select the amount of shift (how much each photo will vary). Spin to the right to separate the three indicator dots by 1 to 3 increments in the horizontal blue/amber axis. Spin to the left to separate the three dots in the vertical green/magenta direction. The bracket amount (BA) will be shown in the BKT box at the right side of the screen.

3. **Select the WB bias.** Unless you adjust the white balance bias, the bracketing will take place along one axis only; that is, blue-to-amber changes or green-to-magenta changes. Each type of adjustment progresses from the center neutral point that's the intersection of axes BA and GM. You can use the left/right and up/down cross keys to add some *bias* to the white balance bracketing (described next).

4. **Confirm your white balance bracketing.** Press INFO to cancel the WB shift/bracketing changes you've made, or press SET to confirm the setting and return to the Shooting 2 menu.

5. **Take your bracket sets.** Subsequent pictures you take will have their white balance bracketed in sets of three, using the parameters you've just entered. The order will be Standard WB (representing the middle dot of the three); more blue/more magenta (either the left or top dot, depending on whether you used the blue/amber or magenta/green axes); more amber/more green.

👍 Tip

If you use the Rebel T3i's continuous shooting feature, you can snap off all three shots in a bracket set quickly and automatically. Note that if High ISO speed noise reduction is set to On in the Custom Functions menu (described in Chapter 4), WB bracketing is disabled.

Color Space

Options: sRGB, Adobe RGB

When you are using one of the Creative Zone modes, you can select one of two different color spaces, which define a specific set of colors that can be applied to the images your T3i captures. The Color Space menu choice applies directly to JPEG images shot using Creative Zone exposure modes (P, Tv, Av, M, and A-DEP). When you're using Basic Zone modes, the T3i uses the sRGB color space for all the JPEG images you take. RAW images are a special case. They have the information for *both* sRGB and Adobe RGB, but when you load such photos into your image editor, it will default to sRGB (with Basic Zone shots) or the color space specified here (for Creative Zone pictures) unless you change that setting while importing the photos.

Picture Style

Options: Auto, Standard, Portrait, Landscape, Neutral, Faithful, Monochrome, User Def 1, User Def 2, User Def 3

The Picture Styles feature allows you to customize the way your T3i renders its photos. Once your styles are set up, Picture Styles are easy to access, and there's no need to visit this menu just to swap one style for another. Just press the Picture Styles button (the down cross key) next to the color LCD, and use the left/right cross keys to move through the list of available styles. As each style is highlighted, its current settings for Sharpness, Contrast, Saturation, and Color Tone are shown at the top of the screen. Press SET to activate the style of your choice.

Press the INFO button, as described below, to adjust these settings. You can also select a Picture Style from the Shooting 2 menu entry (although it takes a few seconds longer).

You'll primarily use this menu item to define or redefine your Picture Styles. (See Figure 3.8.) You can also set up Picture Styles using the T3i's Picture Styles editor within the Digital Photo Pro software.

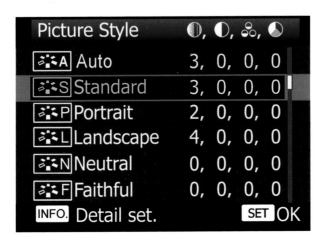

Figure 3.8

Ten different Picture Style settings are available from this scrolling menu; these six plus four styles not shown.

Picture Styles are extremely flexible. Canon has set the parameters for the five predefined color Picture Styles and the single monochrome Picture Style to suit the needs of most photographers. But you can adjust any of those "canned" Picture Styles to settings you prefer. Better yet, you can use those three User Definition files to create brand-new styles that are all your own.

- **Sharpness.** This parameter determines the apparent contrast between the outlines or edges in an image, which we perceive as image sharpness. You can adjust the sharpness of the image between values of 0 (no sharpening added) to 7 (dramatic additional sharpness). When adjusting sharpness, remember that more is not always a good thing. A little softness is necessary (and is introduced by a blurring "anti-alias" filter in front of the sensor) to reduce or eliminate the moiré effects that can result when details in your image form a pattern that is too close to the pattern of the sensor itself. As you boost sharpness, moiré can become a problem, plus, you may end up with those noxious "halos" that appear around the edges of images that have been oversharpened.

- **Contrast.** Use this control, with values from –4 (low contrast) to +4 (higher contrast) to change the number of middle tones between the deepest blacks and brightest whites. Low contrast settings produce a flatter-looking photo,

while high contrast adjustments may improve the tonal rendition while possibly losing detail in the shadows or highlights.

■ **Saturation.** This parameter, adjustable from –4 (low saturation) to +4 (high saturation) controls the richness of the color, making, say, a red tone appear to be deeper and fuller when you increase saturation, and tend more towards lighter, pinkish hues when you decrease saturation of the reds. Boosting the saturation too much can mean that detail may be lost in one or more of the color channels, producing what is called "clipping."

■ **Color tone.** This adjustment has the most effect on skin tones, making them either redder (0 to –4) or yellower (0 to +4).

■ **Filter effect (monochrome only).** Filter effects, accessed by pressing the INFO button, do not add any color to a black-and-white image. Instead, they change the rendition of gray tones as if the picture were taken through a color filter. (See Figure 3.9, left.)

■ **Toning effect (monochrome only).** Using toning effects, also accessed by pressing the INFO button, preserves the monochrome tonal values in your image, but adds a color overlay that gives the photo a sepia, blue, purple, or green cast. (See Figure 3.9, right.)

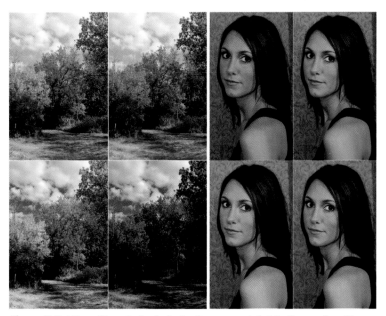

Figure 3.9 Filter effects: Left, clockwise from upper left: No filter; yellow filter; red filter; and green filter. Toning effects: Right, clockwise from upper left: Sepia; blue; green; and purple.

The predefined Picture Styles are as follows: (See Figure 3.8.)

- **Auto.** Adjusts the color to make outdoor scenes look more vivid, with richer colors.
- **Standard.** This Picture Style, the default, applies a set of parameters useful for most picture taking. These parameters are applied automatically when using Basic Zone modes other than Portrait or Landscape.
- **Portrait.** This style boosts saturation for richer colors when shooting portraits, particularly of women and children, while reducing sharpness slightly to provide more flattering skin texture. The Basic Zone Portrait setting uses this Picture Style. You might prefer the Faithful style for portraits of men when you want a more rugged or masculine look, or when you want to emphasize character lines in the faces of older subjects of either gender.
- **Landscape.** This style increases the saturation of blues and greens, and increases both color saturation and sharpness for more vivid landscape images. The Basic Zone Landscape mode uses this setting.
- **Neutral.** This Picture Style is a less saturated and lower contrast version of the Standard style. Use it when you want a more muted look to your images, or when the photos you are taking seem too bright and contrasty (say, at the beach on a sunny day).
- **Faithful.** The goal of this style is to render the colors of your image as accurately as possible, roughly in the same relationships as seen by the eye.
- **Monochrome.** Use this Picture Style to create black-and-white photos in the camera.

Selecting Picture Styles

Canon makes selecting a Picture Style very easy, and, to prevent you from accidentally changing an existing style when you don't mean to, divides *selection* and *modification* functions into two separate tasks. One way to select a Picture Style is to choose Picture Style from the Shooting 2 menu and press SET to produce the main Picture Style menu screen. Use the up/down cross keys to choose from the nine choices. Or, you can press the Picture Styles button (the down cross key) and scroll through the list of available styles. When you use this method, the current settings for a particular style are shown at the top of the screen *only* when you've highlighted that style. Press SET to activate the style of your choice.

Defining Picture Styles

You can change one of the existing Picture Styles or define your own whenever the Shooting 2 menu version of the Picture Styles menu or the pop-up selection screen shown are visible. Just press the INFO button when either screen is on the LCD.

Follow these steps:

1. **Select Style.** Use the cross keys to scroll to the style you'd like to adjust.

2. **Choose Detail set.** Press the INFO button to choose Detail set. If you're coming from the Shooting 2 menu, the screen that appears next will look like the one shown in Figure 3.10 for the five color styles or three User Def styles. If you've accessed the adjustment screen by pressing the Picture Styles button first, the screen looks much the same, but has blue highlighting instead of red.

3. **Specify parameter to change.** Use the cross keys to scroll among the four parameters. Default set. at the bottom of the screen restores the values to the preset numbers.

4. **Adjust parameters.** Change the values of one of the four parameters. If you're redefining one of the default presets, the menu screen will look like the figure, which represents the Landscape Picture Style. Use the left/right cross keys to move the triangle to the value you want to use. Note that the previous value remains on the scale, represented by a gray triangle. This makes it easy to return to the original setting if you want.

5. **Confirm change.** Press the SET button to lock in that value, then press the MENU button two times to back out of the menu system.

Any Picture Style that has been changed from its defaults will be shown in the Picture Style menu with blue highlighting the altered parameter. A quick glance at the Picture Style menu will show you which styles and parameters have been changed.

Figure 3.10
Adjusting Picture Style details.

Making changes in the Monochrome Picture Style is slightly different, as the Saturation and Color tone parameters are replaced with Filter effect and Toning effect options. (Keep in mind that once you've taken a photo using a Monochrome Picture Style, you can't convert the image back to full color.) You can choose from Yellow, Orange, Red, Green filters, or None, and specify Sepia, Blue, Purple, or Green toning, or None. You can still set the Sharpness and Contrast parameters that are available with the other Picture Styles.

Adjusting Styles with the Picture Style Editor

The Picture Style Editor, shown in Figure 3.11, allows you to create your own custom Picture Styles, or edit existing styles, including the Standard, Landscape, Faithful, and other predefined settings already present in your EOS T3i. You can change sharpness, contrast, color saturation, and color tone—and a lot more—and then save the modifications as a PF2 file that can be uploaded to the camera, or used by Digital Photo Professional to modify a RAW image as it is imported.

Figure 3.11 The Picture Style Editor lets you create your own Picture Styles for use by the T3i or Digital Photo Professional when importing image files.

Get More Picture Styles

I've found that careful Googling can unearth other Picture Styles that helpful fellow EOS owners have made available, and even a few from the helpful Canon company itself, such as Studio Portrait, Snapshot Portrait, Nostalgia, Clear, Twilight, Emerald, and Autumn hues.

Dust Delete Data

Options: None (Captures data used to erase dust spots)

This menu choice, the first in the Shooting 3 menu screen, lets you "take a picture" of any dust or other particles that may be adhering to your sensor. The T3i will then append information about the location of this dust to your photos, so that the Digital Photo Professional software can use this reference information to identify dust in your images and remove it automatically. You should capture a Dust Delete Data photo from time to time as your final line of defense against sensor dust.

To use this feature, select Dust Delete Data. Select OK and press the SET button. The camera will first perform a self-cleaning operation by applying ultrasonic vibration to the low-pass filter that resides on top of the sensor. Then, a screen will appear asking you to press the shutter button. Point the T3i at a solid white card with the lens set on manual focus and rotate the focus ring to infinity. When you press the shutter release, the camera takes a photo of the card using Aperture-priority and f/22 (which provides enough depth-of-field [actually, in this case *depth-of-focus*] to image the dust sharply). The "picture" is not saved to your memory card but, rather, is stored in a special memory area in the camera. Finally, a Data obtained screen appears. (See Figure 3.12.) If the Rebel T3i was

Figure 3.12
Capture updated dust data for your sensor to allow Digital Photo Professional to remove it automatically.

unable to capture the data, you'll be asked to repeat the process. Make sure the camera is pointed at a plain white surface that's evenly illuminated.

The Dust Delete Data information is retained in the camera until you update it by taking a new "picture." The T3i adds the information to each image file automatically.

ISO Auto

Options: Max 400, Max 800, Max 1600, Max 3200, Max 6400

This setting specifies the *maximum* ISO sensitivity setting that can be selected automatically when you've set the ISO to Auto using the ISO button on the top panel of the camera (it's located just aft of the Main Dial). When Auto ISO is activated, the camera can bump up the ISO sensitivity, if necessary, whenever an optimal exposure cannot be achieved at the current ISO setting. Of course, it can be disconcerting to think you're shooting at ISO 400 and then see a grainier ISO 1600 shot during LCD review. Use this setting to put the brakes on the ISO setting that can be selected automatically.

You can choose either Auto or one of the listed ISO settings when you press the ISO button while in any Creative Zone shooting mode. Then, rotate the Main Dial to select ISO 100, 200, 400, 800, 1600, 3200, 6400, or Auto. If you've set ISO Expansion to 1: On in the Custom Functions menu (it's C.Fn I-02, as described later in the Set-up 3 menu section in Chapter 4), then one additional ISO setting, ISO 12800 (represented in the menus by the letter H) is available.

Table 3.1 Automatic ISO Ranges	
Shooting Mode	**ISO Range**
Basic Zone modes other than Portrait mode	ISO 100-3200 (Auto)
Portrait mode	ISO 100 (Fixed)
Bulb	ISO 400 (Fixed)
All modes, direct flash	ISO 400 (Fixed, except if over-exposure results, then ISO 100-400)
Program mode/Basic Zone modes except Night Portrait, with bounce flash and external Speedlite	ISO 400-1600 (Auto)
Program, Tv, Av, M modes	ISO 100-6400 (Auto)

(The ISO 12800 setting produces a significant amount of noise, so you should use it with caution.) When one of the numeric ISO settings is selected, the T3i will use only that value.

> **HIGHLIGHT TONE PRIORITY LIMIT**
>
> If you've enabled C.Fn II-06, Highlight tone priority, then only ISO 200-6400 will be selectable.

If you've chosen Auto, instead, then the T3i will select an appropriate ISO value for you, based on the lighting conditions and the shooting mode you're using.

Live View Shooting Settings

This menu entry is the first in the Shooting 4 menu. All of the settings on this tab pertain to the T3i's Live View functions, and will be explained in Chapter 6.

Playback Menu Options

The two blue-coded Playback menus are where you select options related to the display, review, transfer, and printing of the photos you've taken. The choices you'll find include the following:

- Protect images
- Rotate
- Erase images
- Print order
- Creative filters
- Resize

- Histogram
- Image jump with Main Dial
- Slide show
- Rating
- Bass boost
- Ctrl over HDMI

Protect Images

Options: Protect images from erasure

If you want to keep an image from being accidentally erased (either with the Erase button or by using the Erase images menu), you can mark that image for protection. To protect one or more images, press the MENU button and choose Protect. Then use the left/right cross keys to view the image to be protected. Press the SET button to apply the protection. A key icon will appear at the upper edge of the information display while still in the protection screen, and when reviewing that image later (see Figure 3.13). To remove protection, repeat the

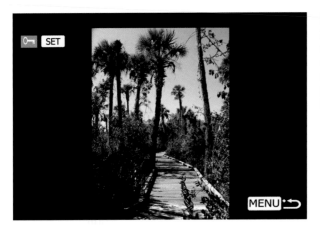

Figure 3.13
Protected images can be locked against accidental erasure (but not preserved from formatting).

process. You can scroll among the other images on your memory card and protect/unprotect them in the same way. Image protection will not save your images from removal when the card is reformatted.

Rotate

Options: Rotate vertical images

While you can set the Rebel T3i to automatically rotate images taken in a vertical orientation using the Auto rotate option in the Set-up menu, if you've done so you can manually rotate an image during playback using this menu selection. Select Rotate from the Playback menu, use the left/right cross keys to page through the available images on your memory card until the one you want to rotate appears, then press SET. The image will appear on the screen rotated 90 degrees. Press SET again, and the image will be rotated 270 degrees.

Erase Images

Options: Remove images

Choose this menu entry and you'll be given three choices: Select and erase images, All Images in Folder, and All images on card. The former option displays the most recent image. Press the up/down cross keys to mark or unmark an image for deletion (a check mark will appear in a box in the upper-left corner). Then, use the left/right cross keys to view other images and mark/unmark them for deletion. If you try to mark a protected image for deletion, a warning Protected appears on the screen.

When finished marking pictures, press the Trash button, and you'll see a screen that says Erase selected images with two options, Cancel and OK. Choose OK, then press the SET button to erase the images, or select Cancel and press the SET button to return to the selection screen. Press the MENU button to unmark your selections and return to the menu.

The All images on card choice removes all the pictures on the card, except for those you've marked with the Protect command, and does not reformat the memory card.

Print Order

Options: Choose images to be printed using DPOF

The Rebel T3i supports the DPOF (Digital Print Order Format) that is now almost universally used by digital cameras to specify which images on your memory card should be printed, and the number of prints desired of each image. This information is recorded on the memory card, and can be interpreted by a compatible printer when the camera is linked to the printer using the USB cable, or when the memory card is inserted into a card reader slot on the printer itself. Photo labs are also equipped to read this data and make prints when you supply your memory card to them.

Creative Filters

This menu entry allows you to apply some interesting effects to images you've already taken, and save a copy alongside the original. When you select this menu entry, you'll be taken to a screen that allows you to choose an image to modify. You can scroll through the available images with the cross keys or press the Thumbnail/Reduce Image button to view thumbnails and select from those. Only images that can be edited resized are shown. Then, press SET, and choose the filter you want to apply from a list at the bottom of the screen using the left/right cross key buttons. Press SET to activate the filter, then use the left/right buttons again to adjust the amount of the effect (or select the area to be adjusted using the miniature effect). Press SET once more to save your new image.

The four effects include the following.

- **Grainy B/W.** Creates a grainy monochrome image. You can adjust contrast among Low, Normal, and Strong settings.
- **Soft Focus.** Blur your image using Low, Normal, and Strong options.
- **Fish-eye Effect.** Creates a distorted, curved image.

■ **Toy Camera Effect.** Darkens the corners of an image, much as a toy camera does, and adds a warm or cool tone (or none), as you wish.

■ **Miniature Effect.** This is a clever effect, and it's hampered by a misleading name and the fact that its properties are hard to visualize (which is not a great attribute for a visual effect). This tool doesn't create a "miniature" picture, as you might expect. What it does is mimic tilt/shift lens effects that angle the lens off the axis of the sensor plane to drastically change the plane of focus, producing the sort of look you get when viewing some photographs of a diorama, or miniature scene. Confused yet? All you need to do is specify the area of the image that you want to remain sharp.

Resize

If you've already taken an image and would like to create a smaller version (say, to send by e-mail), you can create one from this menu entry. Just follow these steps:

1. **Choose Resize.** Select this menu entry from the Playback 1 menu.

2. **View images to resize**. You can scroll through the available images with the cross keys, or press the Thumbnail/Reduce Image button to view thumbnails and select from those. Only images that can be resized are shown. They include JPEG Large, Medium, Small 1, and Small 2 images. Small 3 and RAW images of any type cannot be resized.

3. **Select an image.** Press SET to select an image to resize. A pop-up menu will appear on the screen offering the choice of reduced size images. These include M (Medium: 8MP, 3456 × 2304 pixels); S1 (Small 1: 4.5MP, 2592 × 1728 pixels); S2 (Small 2: 2.5MP, 1920 × 1280 pixels); or S3 (Small 3, .3MP, 720 × 480 pixels). You cannot resize an image to a size that is larger than its current size; that is, you cannot save a JPEG Medium image as JPEG Large.

4. **Resize and save.** Press SET to save as a new file, and confirm your choice by selecting OK from the screen that pops up, or cancel to exit without saving a new version. The old version of the image is untouched.

Histogram

Options: Brightness/RGB histograms

This entry is the first on the Playback 2 menu. The T3i can show either a brightness histogram or a set of three separate red, green, and blue histograms in the full information display during picture review, or, it can show you both types of histogram in the partial information display.

Brightness histograms give you information about the overall tonal values present in the image. The RGB histograms can show more advanced users valuable data about specific channels that might be "clipped" (details are lost in the shadows or highlights). This menu choice determines only how they are displayed during picture review. The amount of information displayed cycles through the following list as you repeatedly press the INFO button.

- **Image only.** In this view, only the image is displayed, with no additional information.

- **Single image display.** Only the image itself is shown, with basic shooting information overlaid on the photo, as you can see at upper left in Figure 3.14.

- **Histogram display.** Both RGB and brightness histograms are shown, along with partial shooting information. This menu choice has no effect on the histograms shown in this display, which you can see at upper right in Figure 3.14.

- **Shooting information display.** Full shooting data is shown, along with either a brightness histogram (bottom left in Figure 3.14) or RGB histogram (bottom right in Figure 3.14). The type of histogram on view in this screen is determined by the setting you make in this menu choice. Select Histogram from the Playback 2 menu and choose Brightness or RGB.

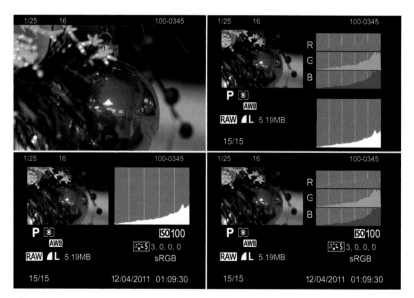

Figure 3.14 Press the INFO button to cycle between single image display (upper left); histogram display (upper right); shooting information display with brightness histogram (bottom left); or RGB histogram (bottom right).

Image Jump with Main Dial

Options: 1 image, 10 images, 100 images, Date, Movies, Stills, Rating

As first described in Chapter 1, you can leap ahead or back during picture review by rotating the Main Dial, using a variety of increments, which you can select using this menu entry. The jump method is shown briefly on the screen as you leap ahead to the next image displayed, as shown in Figure 3.15.

You can change the jump increment on the fly while reviewing images, simply by pressing the up cross key. Rotate the Main Dial when the message shown in the figure is visible to make the adjustment. Or, you can change the jump increment in this menu. In either case, your options are as follows:

- **1 image.** Rotating the Main Dial one click jumps forward or back 1 image.
- **10 images.** Rotating the Main Dial one click jumps forward or back 10 images.
- **100 images.** Rotating the Main Dial one click jumps forward or back 100 images.
- **Date.** Rotating the Main Dial one click jumps forward or back to the first image taken on the next or previous calendar date.
- **Folder.** Rotating the Main Dial one click jumps forward or back to the first image in the next folder available on your memory card (if one exists).
- **Movies.** Rotating the Main Dial one click jumps forward or back, displaying movies you captured only.

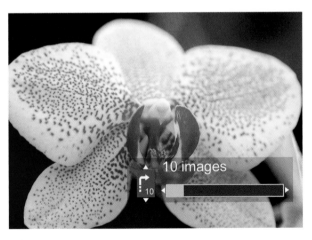

Figure 3.15
The jump method can be changed when you press the up cross key during image review.

- **Stills.** Rotating the Main Dial one click jumps forward or back, displaying still images only.

- **Rating.** Rotating the Main Dial one click jumps forward or back, displaying images by the ratings you've applied. Rotate the Main Dial to choose the rating parameter.

Slide Show

Options: Select images, display time, and repeat settings

Slide show is a convenient way to review images one after another, without the need to manually switch between them. To activate, just choose Slide show from the Playback 1 menu. During playback, you can press the SET button to pause the "slide show" (in case you want to examine an image more closely), or the INFO button to change the amount of information displayed on the screen with each image. For example, you might want to review a set of images and their histograms to judge the exposure of the group of pictures.

To set up your slide show, follow these steps:

1. **Begin set up.** Choose Slide show from the Playback 1 menu, pressing SET to display the screen shown in Figure 3.16.

2. **Choose image selection method.** Rotate the Main Dial to All images, and press SET. Then use the cross keys to choose from All images, Stills, Movies, or Date. If you select All images, both movies and stills will show in the order captured. Press SET to activate that selection mode. If you selected All images, skip to Step 4.

Figure 3.16
Set up your slide show using this screen.

3. **Choose images.** If you've selected Date, press the INFO button to produce a screen that allows you to select from the available image creation dates on your memory card. When you've chosen a date, press SET to confirm your choice.

4. **Choose Play time and Repeat options.** Navigate to highlight Set-up and press SET to produce a screen with playing time (1 sec, 2 sec, 3 sec, or 5 sec per image), and repeating options (On or Off). When you've specified either value, press the MENU button to confirm your choice, and then MENU once more to go back to the main slide show screen.

5. **Start the show.** Highlight Start and press SET to begin your show. (If you'd rather cancel the show you've just set up, press MENU instead.)

6. **Use show options during display.** Press SET to pause/restart; INFO to cycle among the four information displays described in the section before this one; MENU to stop the show.

Ctrl over HDMI

Options: Disable, Enable

If you own an HDTV that is compatible with the HDMI CEC (Consumer Electronics Control), then you can use the set's remote to control your camera's playback functions when the two are connected using an HDMI cable. This menu item allows you to enable or disable this feature.

When active, all you need to do is connect your camera and the HDTV, which should automatically switch to the HDMI input attached to the EOS Rebel T3i. (Most HDTVs have several HDMI inputs; you may also have a switch or switch-box to select one of several inputs.) Press the Playback button on the camera, and you can view menus on your television that will allow you to select still images or movies, activate slide shows, and perform other functions. Note that some HDTVs also require you to activate the HDMI CEC capability using the set's controls, and that not all HDMI CEC "compatible" televisions can interface with your camera. Your best bet is to just try it.

If you don't have an HDTV, you can also view the output of your camera (but not control the camera) through your standard-definition television by connecting the A/V Out/Digital terminal of the camera to the red/white (audio) and yellow (composite video) jacks of your set. Press the Playback button to view. You must also use the Set-up 2 menu's Video System entry (described in Chapter 4) to specify the type of video system used in your country (either NTSC or PAL). This menu entry has no effect when viewing your T3i's video/audio output on a standard definition television.

Chapter 4

Set-up 1, 2, 3, and My Menu Settings

This chapter shows you how and why to use each of the options in the Set-up and My Menu sections of your T3i's menu system.

Set-up 1, 2, and 3 Menu Options

There are three yellow/gold-coded Set-up menus where you make adjustments on how your camera *behaves* during your shooting session, as differentiated from the Shooting menu, which adjusts how the pictures are actually taken. Your choices include the following:

- Auto power off
- Auto rotate
- Format
- File numbering
- Select folder
- Screen color
- Eye-Fi settings
- LCD brightness
- LCD off/on button

- Date/Time
- Language
- Video system
- Sensor cleaning
- Feature Guide
- Custom Functions
- Copyright information
- Clear settings
- Firmware Ver.

Auto Power Off

Options: 30 seconds, 1 min., 2 min., 4 min., 8 min., 15 min., Off

This menu entry is the first in the Set-up 1 menu (see Figure 4.1). It allows you to determine how long the Rebel T3i remains active before shutting itself off. You can select 30 sec., 1 min., 2 min., 4 min., 8 min., or 15 min., or Off, which leaves the camera turned on indefinitely—or until 30 minutes have passed.

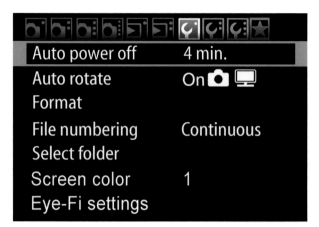

Figure 4.1
Select an automatic shut-off period to save battery power.

However, even if the camera has shut itself off, if the power switch remains in the On position, you can bring the camera back to life by pressing the shutter button halfway, or several other buttons, including the DISP, MENU, or Playback buttons.

Auto Rotate

Options: Camera/Computer, Computer Only, Off

You can turn this feature On or Off. When activated, the Rebel T3i rotates pictures taken in vertical orientation on the LCD screen so you don't have to turn the camera to view them comfortably. However, this orientation also means that the longest dimension of the image is shown using the shortest dimension of the LCD, so the picture is reduced in size. You have three options. The image can be autorotated when viewing in the camera *and* on your computer screen using your image editing/viewing software. The image can be marked to autorotate *only* when reviewing your image in your image editor or viewing software. This option allows you to have rotation applied when using your computer, while retaining the ability to maximize the image on your LCD in the camera. The third choice is Off. The image will not be rotated when displayed in the camera or with your computer. Note that if you switch Auto rotate off, any pictures shot while the feature is disabled will not be automatically rotated when you turn Auto rotate back on; information embedded in the image file when the photo *is taken* is used to determine whether autorotation is applied. (See Figure 4.2.)

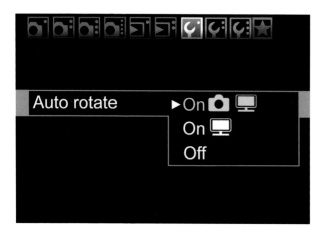

Figure 4.2
Choose auto rotation both in the camera and on your computer display (top); only on your computer display (middle); or no automatic rotation (bottom).

Format

Options: Cancel, OK

Use this item to erase everything on your memory card and set up a fresh file system ready for use. When you select Format, you'll see a display like Figure 4.3, showing the capacity of the card, how much of that space is currently in use, and two choices at the bottom of the screen to Cancel or OK (proceed with the format). A yellow-gold bar appears on the screen to show the progress of the formatting step. (The optional low level format invoked with the Trash button is a slower, but more thorough reformatting that can help restore a memory card that has picked up some bad sectors that aren't locked out by the normal format step.)

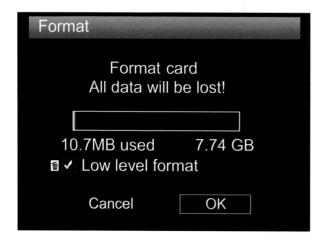

Figure 4.3
You must confirm the format step before the camera will erase a memory card.

File Numbering

Options: Continuous, Automatic reset, Manual reset

The Rebel T3i will automatically apply a file number to each picture you take, using consecutive numbering for all your photos over a long period of time, spanning many different memory cards, starting over from scratch when you insert a new card, or when you manually reset the numbers. Numbers are applied from 0001 to 9999, at which time the camera creates a new folder on the card (100, 101, 102, and so forth), so you can have 0001 to 9999 in folder 100, then numbering will start over in folder 101.

The camera keeps track of the last number used in its internal memory. That can lead to a few quirks you should be aware of. For example, if you insert a memory card that had been used with a different camera, the T3i may start numbering with the next number after the highest number used by the previous camera. (I once had a brand new Canon camera start numbering files in the 8,000 range.) I'll explain how this can happen next.

On the surface, the numbering system seems simple enough: In the menu, you can choose Continuous, Automatic reset, or Manual reset.

- **Continuous.** If you're using a blank/reformatted memory card, the T3i will apply a number that is one greater than the number stored in the camera's internal memory. If the card is not blank and contains images, then the next number will be one greater than the highest number on the card *or* in internal memory. (In other words, if you want to use continuous file numbering consistently, you must always use a card that is blank or freshly formatted.)

- **Automatic reset.** If you're using a blank/reformatted memory card, the next photo taken will be numbered 0001. If you use a card that is not blank, the next number will be one greater than the highest number found on the memory card. Each time you insert a memory card, the next number will either be 0001 or one higher than the highest already on the card.

- **Manual reset.** The T3i creates a new folder numbered one higher than the last folder created, and restarts the file numbers at 0001. Then, the camera uses the numbering scheme that was previously set, either Continuous or Automatic reset, each time you subsequently insert a blank or non-blank memory card.

Select Folder

Options: Choose or Create Folder

Choose this menu option to create a folder where the images you capture will be stored on your memory card, or to switch between existing folders. Just follow these steps:

1. **Choose Select Folder.** Access the option from the Set-up 1 menu.
2. **View list of available folders.** The Select Folder screen pops up with a list of the available folders on your memory card, with names like 100EOST3i, 101EOST3i, etc.
3. **Choose a different folder.** To store subsequent images in a different existing folder, use the cross keys to highlight the label for the folder you want to use. When a folder that already has photos is selected, two thumbnails representing images in that folder are displayed at the right side of the screen.
4. **Confirm the folder.** Press SET to confirm your choice of an existing folder.
5. **Create new folder.** If you'd rather create a new folder, highlight Create Folder in the Select Folder screen and press SET. The name of the folder that will be created is displayed, along with a choice to Cancel or OK creating the folder. Press SET to confirm your choice.
6. **Exit.** Press MENU to return to the Set-up 1 menu.

Screen Color

Options: White text on black, white text on blue, black text on tan

If you find the default color scheme for the shooting settings display (black text on white) distracting or hard to read, you can change to one of three alternates: white text on black, white text on dark blue, and black text on tan.

Eye-Fi Settings

Options: Enable, Disable, Connection info (when enabled)

This is the first of two "hidden" menus, and appears only when you have an Eye-Fi wireless transmitter SD card inserted in the T3i. (The second hidden menu is the Movie Settings menu, which appears only when the Mode Dial is set to the Movie position.)

When an Eye-Fi card is present in the camera, the menu choices are Enable and Disable, which turn the T3i's use of the card's transmission capabilities on and off. If you select Enable, an additional menu choice appears, Connection info., which shows the status of the card's link with available wireless networks.

LCD Brightness

Options: Adjust brightness

Choose this menu option, the first on the second Set-up menu tab (see Figure 4.4), to view a thumbnail image accompanied by a grayscale strip. Use the left/right cross keys to adjust the brightness to a comfortable viewing level. Brighter settings use more battery power, but can allow you to view an image on the LCD outdoors in bright sunlight. When you have the brightness you want, press the SET button to lock it in and return to the menu. (See Figure 4.5.)

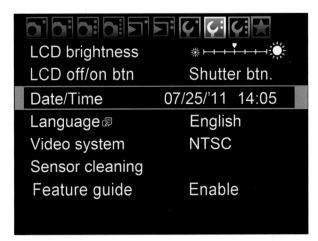

Figure 4.4
The Set-up 2 menu.

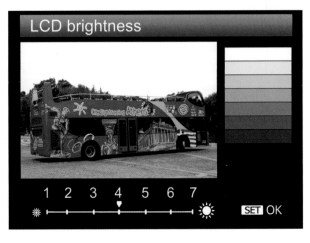

Figure 4.5
Adjust LCD brightness for easier viewing under varying ambient lighting conditions.

LCD Off/On Button

Options: Shutter button alone, shutter button plus DISP, or Remains On

Choose which buttons can be used to turn the LCD on or off. Your choices are the shutter button alone, the shutter button plus the DISP button, or Remains on (the LCD does not shut off).

Date/Time

Options: Set date, time, date format

Use this option to set the date and time, which will be embedded in the image file along with exposure information and other data. I showed you how to do this in Chapter 1.

Language

Options: 25 languages

Choose from 25 languages for menu display, rotating the Main Dial until the language you want to select is highlighted. Press the SET button to activate. Your choices include English, German, French, Dutch, Danish, Portuguese, Finnish, Italian, Ukrainian, Norwegian, Swedish, Spanish, Greek, Russian, Polish, Czech, Magyar, Romanian, Turkish, Arabic, Thai, Simplified Chinese, Traditional Chinese, Korean, and Japanese.

Video System

Options: On, Off

This setting controls the output of the T3i through the AV cable when you're displaying images on an external standard definition television or monitor. You can select either NTSC, used in the United States, Canada, Mexico, many Central, South American, and Caribbean countries, much of Asia, and other countries; or PAL, which is used in the UK, much of Europe, Africa, India, China, and parts of the Middle East.

Sensor Cleaning

Options: Auto cleaning Enable/Disable, Clean now, Clean manually

One of the Canon EOS Rebel T3i's best features is the automatic sensor cleaning system that reduces or eliminates the need to clean your camera's sensor manually. Canon has applied anti-static coatings to the sensor and other portions of the camera body interior to counter charge build-ups that attract dust.

A separate filter over the sensor vibrates ultrasonically each time the T3i is powered on or off, shaking loose any dust, which is captured by a sticky strip beneath the sensor.

Use this menu entry to enable or disable automatic sensor cleaning on power up (select Auto cleaning to choose power-up cleaning) or to activate automatic cleaning during a shooting session (select Clean now). You can also choose the Clean manually option to flip up the mirror and clean the sensor yourself with a blower, brush, or swab. If the battery level is too low to safely carry out the cleaning operation, the T3i will let you know and refuse to proceed, unless you use the optional AC adapter kit. (See Figure 4.6.)

Figure 4.6
Use this menu choice to activate automatic sensor cleaning or enable/disable it on power up.

Feature Guide

Options: Enable, Disable

The Feature Guide is an easy pop-up description of a function or option that appears when you change the shooting mode or use the quick control screen to select a function, switch to Live view, movie making, or playback. The instructional screen quickly vanishes in a few seconds. You can use this setting to enable or disable the Feature Guide.

Custom Functions I/II/III/IV

Custom Functions, the first choice in the Set-up 3 menu, let you customize the behavior of your camera in a variety of different ways, ranging from whether or not the flash fires automatically to the function carried out when the SET button is pressed. If you don't like the default way the camera carries out a

particular task, you just may be able to do something about it. You can find the Custom Functions in their own screen with 13 choices, divided into four groups of settings: Exposure (I, C.Fn 01, 02, and 03); Image (II, C.Fn 04, 05, and 06); Autofocus/Drive (III, C.Fn 07 and 08); and Operation/Others (IV, C.Fn 09, 10, 11, and 12). The Roman numeral divisions within a single screen with a single line of choices seem odd until you realize that some other more upscale Canon EOS models (such as the EOS 50D) separate each of these groups into separate screens (with larger numbers of options).

Each of the Custom Functions is set in exactly the same way, so I'm not going to bog you down with a bunch of illustrations showing how to make this setting or that. One quick run-through using Figure 4.7 should be enough. Here are the key parts of the Custom Functions screen.

■ **Custom Function category.** At the top of the settings screen is a label that tells you which category that screen represents.

■ **Current Function name.** Use the left/right cross keys to select the function you want to adjust. The name of the function currently selected appears at the top of the screen, and its number is marked with an over score in the row of numbers at the bottom of the screen. You don't need to memorize the function numbers.

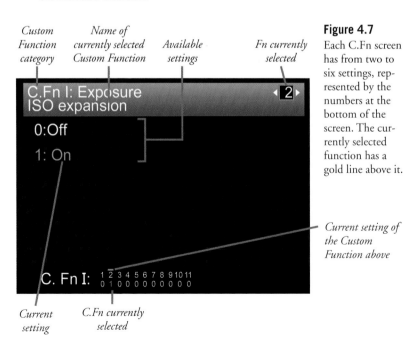

Custom Function category *Name of currently selected Custom Function* *Available settings* *Fn currently selected*

Current setting *C.Fn currently selected*

Current setting of the Custom Function above

Figure 4.7
Each C.Fn screen has from two to six settings, represented by the numbers at the bottom of the screen. The currently selected function has a gold line above it.

■ **Function currently selected.** The function number appears in two places. In the upper-right corner you'll find a box with the current function clearly designated. In the lower half of the screen are two lines of numbers. The top row has numbers from 1 to 12, representing the Custom Function. The second row shows the number of the current setting. If the setting is other than the default value (a zero), it will be colored blue, so you can quickly see which Custom Functions have been modified. The currently selected function will have a gold line above it.

■ **Available settings.** Within the alternating medium gray/dark gray blocks appear numbered setting options. The current setting is highlighted in blue. You can use the up/down cross keys to scroll to the option you want and then press the SET button to select it; then press the MENU button twice to back out of the Custom Functions menus.

■ **Current setting.** Underneath each Custom Function is a number from 0 to 5 that represents the current setting for that function.

■ **Option selection.** When a function is selected, the currently selected option appears in a highlighted box. As you scroll up and down the option list, the setting in the box changes to indicate an alternate value.

In the listings that follow, I'm going to depart from the sometimes-cryptic labels Canon assigns to each Custom Function in the menu, and instead categorize them by what they actually do. I'm also going to provide you with a great deal more information on each option and what it means to your photography.

C.Fn I-01: Size of Exposure Adjustments

Options: 1/3 stop, 1/2 stop

Exposure level increments. This setting tells the Rebel T3i the size of the "jumps" it should use when making exposure adjustments—either one-third or one-half stop. The increment you specify here applies to f/stops, shutter speeds, EV changes, and autoexposure bracketing.

■ **0: 1/3 stop.** Choose this setting when you want the finest increments between shutter speeds and/or f/stops. For example, the T3i will use shutter speeds such as 1/60th, 1/80th, 1/100th, and 1/125th second, and f/stops such as f/5.6, f/6.3, f/7.1, and f/8, giving you (and the autoexposure system) maximum control.

■ **1: 1/2 stop.** Use this setting when you want larger and more noticeable changes between increments. The T3i will apply shutter speeds such as 1/60th, 1/125th, 1/250th, and 1/500th second, and f/stops including f/5.6, f/6.7, f/8, f/9.5, and f/11. These coarser adjustments are useful when you want more dramatic changes between different exposures.

C.Fn I-02: Whether ISO 12800 Is Available or Disabled

Options: Off, On

ISO expansion. Ordinarily, only ISO settings from 100 to 6400 are available (ISO 200-6400 if C.Fn II-6: Highlight Tone Priority is enabled). The ISO expansion function is disabled by default to prevent you from unintentionally using ISO settings higher than ISO 6400. If you want to use the H (ISO 12800) setting, it must be activated using this Custom Function. I've found the noise produced at the ISO 6400 setting on my EOS T3i to be quite acceptable under certain situations, and ISO 12800 can be useable. That's particularly so with images of subjects that have a texture of their own that tends to hide or mask the noise.

CAUTION

Be aware that if you've activated Highlight Tone Priority (described later), the H setting (and ISO values less than ISO 200) will not be available even if you have enabled ISO expansion.

- **0: Off.** The H (ISO 12800) setting is locked out and not available when using the ISO button or menu options.
- **1: On.** The H settings (equivalent to ISO 12800) can be selected.

C.Fn I-03: Flash Synchronization Speed when Using Aperture-Priority

Options: Auto, 1/200-1/60 sec., 1/200 sec. (fixed)

Flash sync. speed in Av mode. You'll find this setting useful when using flash. When you're set to Aperture-priority mode (Av), you select a fixed f/stop and the Rebel T3i chooses an appropriate shutter speed. That works fine when you're shooting by available light. However, when you're using flash, the flash itself provides virtually all of the illumination that makes the main exposure, and the shutter speed determines how much, if any, of the ambient light contributes to a second, non-flash exposure. Indeed, if the camera or subject is moving, you can end up with two distinct exposures in the same frame: the sharply defined flash exposure, and a second, blurry "ghost" picture created by the ambient light.

If you *don't* want that second exposure, you should use the highest shutter speed that will synchronize with your flash (that's 1/200th second with the Rebel T3i). If you do want the ambient light to contribute to the exposure (say, to allow the background to register in night shots, or to use the ghost image as a special

effect), use a slower shutter speed. For brighter backgrounds, you'll need to put the camera on a tripod or other support to avoid the blurry ghosts.

- **0: Auto.** The T3i will vary the shutter speed in Av mode, allowing ambient light to partially illuminate the scene in combination with the flash exposure. Use a tripod, because shutter speeds slower than 1/60th second may be selected.

- **1: 1/200-1/60 sec. (auto).** The camera will use a shutter speed from 1/200th second (to virtually eliminate ambient light) to 1/60th second (to allow ambient light to illuminate the picture). This compromise allows a slow enough shutter speed to permit ambient light to contribute to the exposure, but blocks use of shutter speeds slower than 1/60th second, to minimize the blurriness of the secondary, ambient light exposure.

- **2: 1/200th sec. (fixed).** The camera always uses 1/200th second as its shutter speed in Av mode, reducing the effect of ambient light and, probably, rendering the background dark.

C.Fn II-04: Reducing Noise Effects at Shutter Speeds of One Second or Longer

Options: Off, Auto, On

Long exposure noise reduction. Visual noise is that graininess that shows up as multicolored specks in images, and this setting helps you manage it. Noise can be produced from high ISO settings. As the captured information is amplified to produce higher ISO sensitivities, some random noise in the signal is amplified along with the photon information. Increasing the ISO setting of your camera raises the threshold of sensitivity so that fewer and fewer photons are needed to register as an exposed pixel. Yet, that also increases the chances of one of those phantom photons being counted among the real-life light particles, too.

A second way noise is created is through longer exposures. Extended exposure times allow more photons to reach the sensor, but increase the likelihood that some photosites will react randomly even though not struck by a particle of light. Moreover, as the sensor remains switched on for the longer exposure, it heats, and this heat can be mistakenly recorded as if it were a barrage of photons. This Custom Function can be used to tailor the amount of noise-canceling performed by the digital signal processor.

- **0: Off.** Disables long exposure noise reduction. Use this setting when you want the maximum amount of detail present in your photograph, even though higher noise levels will result. This setting also eliminates the extra time needed to take a picture caused by the noise reduction process. If you

plan to use only lower ISO settings (thereby reducing the noise caused by ISO amplification), the noise levels produced by longer exposures may be acceptable.

■ **1: Auto.** The Rebel T3i examines your photo taken with an exposure of one second or longer, and if long exposure noise is detected, a second, blank exposure is made and compared to the first image. Noise found in the "dark frame" image is subtracted from your original picture, and only the noise-corrected image is saved to your memory card.

■ **2: On.** When this setting is activated, the T3i applies dark frame subtraction to all exposures longer than one second. You might want to use this option when you're working with high ISO settings (which will already have noise boosted a bit) and want to make sure that any additional noise from long exposures is eliminated, too. Noise reduction will be applied to some exposures that would not have caused it to kick in using the Auto setting.

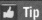 **Tip**

While the "dark frame" is being exposed, the LCD screen will be blank during Live View mode, and the number of shots you can take in continuous shooting mode will be reduced. White balance bracketing is disabled during this process.

C.Fn II-05: Eliminating Noise Caused by Higher ISO Sensitivities

Options: Standard, Low, Strong, Disable

High ISO speed noise reduct'n. This setting applies noise reduction that is especially useful for pictures taken at high ISO sensitivity settings. The default is 0: Standard noise reduction, but you can specify 1: Low or 2: Strong noise reduction, or Disable noise reduction entirely. At lower ISO values, noise reduction improves the appearance of shadow areas without affecting highlights; at higher ISO settings, noise reduction is applied to the entire photo. Note that when the 2: Strong option is selected, the maximum number of continuous shots that can be taken will decrease significantly, because of the additional processing time for the images.

■ **0: Standard.** At lower ISO values, noise reduction is applied primarily to shadow areas; at higher ISO settings, noise reduction affects the entire image.

■ **1: Low.** A smaller amount of noise reduction is used. This will increase the grainy appearance, but preserve more fine image detail.

- **2: Strong.** More aggressive noise reduction is used, at the cost of some image detail, adding a "mushy" appearance that may be noticeable and objectionable. Because of the image processing applied by this setting, your continuous shooting maximum burst will decrease significantly.
- **3: Disable.** No additional noise reduction will be applied.

C.Fn II-06: Improving Detail in Highlights
Options: Disable, Enable

Highlight Tone Priority. This setting concentrates the available tones in an image from the middle grays up to the brightest highlights, in effect expanding the dynamic range of the image at the expense of shadow detail. You'd want to activate this option when shooting subjects in which there is lots of important detail in the highlights, and less detail in shadow areas. Highlight tones will be preserved, while shadows will be allowed to go dark more readily (and may exhibit an increase in noise levels). Bright beach or snow scenes, especially those with few shadows (think high noon, when the shadows are smaller) can benefit from using Highlight Tone Priority.

- **0: Disable.** The Rebel T3i's normal dynamic range is applied.
- **1: Enable.** Highlight areas are given expanded tonal values, while the tones available for shadow areas are reduced. The ISO 100 sensitivity setting is disabled and only ISO 200-ISO 6400 are available. You can tell that this restriction is in effect by viewing the **D+** icon shown in the viewfinder, on the ISO Selection screen, and in the shooting information display for a particular image.

C.Fn III-07: Activation of the Autofocus Assist Lamp
Options: Emits, Does not emit, Only external flash emits, IR AF-assist beam only

Activation of autofocus assist beam. This setting determines when the AF-assist lamp in the camera or an external flash is activated to emit a pulse of light prior to the main exposure that helps provide enough contrast for the Rebel T3i to focus on a subject.

- **0: Emits.** The AF-assist light is emitted by the camera's built-in flash whenever light levels are too low for accurate focusing using the ambient light.
- **1: Does not emit.** The AF-assist illumination is disabled. You might want to use this setting when shooting at concerts, weddings, or darkened locations where the light might prove distracting or discourteous.

■ **2: Only external flash emits.** The built-in AF-assist light is disabled, but if a Canon EX dedicated flash unit is attached to the camera, its AF-assist feature (a flash pulse) will be used when needed. Because the flash unit's AF-assist is more powerful, you'll find this option useful when you're using flash and are photographing objects in dim light that are more than a few feet away from the camera (and thus not likely to be illuminated usefully by the Rebel T3i's built-in light source). Note that if AF-assist beam firing is disabled within the flash unit's own Custom Functions, this setting will not override that.

■ **3: IR AF-assist beam only.** Canon dedicated Speedlites with an infrared assist beam can be set to use only the IR assist burst. That will keep other flash bursts from triggering the AF-assist beam.

C.Fn III-08: Whether It Is Possible to Lock Up the Viewing Mirror Prior to an Exposure

Options: Disable, Enable

Mirror lockup. This function determines whether the reflex viewing mirror will be flipped up out of the way in advance of taking a picture, thereby eliminating any residual blurring effects caused by the minuscule amount of camera shake that can be produced if (as is the case normally) the mirror is automatically flipped up an instant before the actual exposure. When shooting telephoto pictures with a very long lens, or close-up photography at extreme magnifications, even this tiny amount of vibration can have an impact.

You'll want to make this adjustment immediately prior to needing the mirror lockup function, because once it's been enabled, the mirror *always* flips up, and picture taking becomes a two-press operation. That is, you press the shutter release once to lock exposure and focus, and to swing the mirror out of the way. Your viewfinder goes blank (of course, the mirror's blocking it). Press the shutter release a second time to actually take the picture. Because the goal of mirror lockup is to produce the sharpest picture possible, and because of the viewfinder blackout, you can see that the camera should be mounted on a tripod prior to taking the picture, and, to avoid accidentally shaking the camera yourself, using an off-camera shutter release mechanism is a good idea.

■ **0: Disable.** Mirror lockup is not possible.

■ **1: Enable.** Mirror lockup is activated and will be used for every shot until disabled.

Here are some warnings to keep in mind:

- **Don't use ML for sensor cleaning.** Though locked up, the mirror will flip down again automatically after 30 seconds, which you don't want to happen while you're poking around the sensor with a brush, swab, or air jet. There's a separate menu item—Sensor Cleaning—for sensor housekeeping.

- **Avoid long exposure to extra-bright scenes.** The shutter curtain, normally shielded from incoming light by the mirror, is fully exposed to the light being focused on the focal plane by the lens mounted on the T3i. When the mirror is locked up, you certainly don't want to point the camera at the sun, and even beach or snow scenes may be unsafe if the shutter curtain is exposed to their illumination for long periods.

- **ML can't be used in continuous shooting modes.** The Rebel T3i will use single shooting mode for mirror lockup exposures, regardless of the sequence mode you've selected.

- **Use self-timer to eliminate second button press.** If you've activated the self-timer, the mirror will flip up when you press the shutter button down all the way, and then the picture will be taken two seconds later. This technique can help reduce camera shake further if you don't have a remote release available and have to use a finger to press the shutter button. You can also use the Remote Controller RC-5- or RC-6. With the RC-5, press the transmit button to lock up the mirror; the shot will be taken automatically two seconds later. With the RC-6, set the remote for a two-second delay to produce the same effect.

C.Fn IV-09: What Happens When You Partially Depress the Shutter Release/Press the AE Lock Button

Options: AF/AE lock, AE lock/AF, AF/AF lock—no AE lock, AE/AF—no AE lock

Shutter button/AE lock button (*). This setting controls the behavior of the shutter release and the AE lock button (*) when you are using Creative Zone exposure modes. With Basic Zone modes, the Rebel T3i always behaves as if it has been set to Option 0, described below. Options 1, 2, and 3 are designed to work with AI Servo mode, which locks focus as it is activated, but refocuses if the subject begins to move. The options allow you to control exactly when focus and exposure are locked when using AI Servo mode.

In the option list, the first action in the pair represents what happens when you press the shutter release; the second action says what happens when the AE lock button is pressed.

■ **0: AF/AE lock.** With this option, pressing the shutter release halfway locks in focus; pressing the * button locks exposure. Use this when you want to control each of these actions separately.

■ **1: AE lock/AF.** Pressing the shutter release halfway locks exposure; pressing the * button locks autofocus. This setting swaps the action of the two buttons compared to the default 0 option.

■ **2: AF/AF lock—no AE lock.** Pressing the AE lock button interrupts the autofocus and locks focus in AI Servo mode. Exposure is not locked at all until the actual moment of exposure when you press the shutter release all the way. This mode is handy when moving objects may pass in front of the camera (say, a tight end crosses your field of view as you focus on the quarterback) and you want to be able to avoid change of focus. Note that you can't lock in exposure using this option.

■ **3: AE/AF—no AE lock.** Pressing the shutter release halfway locks in autofocus, except in AI Servo mode, in which you can use the * button to start or stop autofocus. Exposure is always determined at the moment the picture is taken, and cannot be locked.

C.Fn IV-10: Using the SET Button as a Function Key

Options: Disabled, Image quality, Flash exposure comp., LCD Monitor on/off, Menu display, ISO speed

Assign SET button. You already know that the SET button is used to select a choice or option when navigating the menus. However, when you're taking photos, it has no function at all. You can easily remedy that with this setting. This setting allows you to assign one of five different actions to the SET key. Because the button is within easy reach of your right thumb, that makes it quite convenient for accessing a frequently used function. When this Custom Function is set to 5, the SET button has no additional function during shooting mode (except to activate Live View when it is turned on), and options 0 through 4 assign an action to the button during shooting.

■ **0: Disabled.** This is the default during shooting; no action is taken. (If you have used the T1i, you know that this choice activated the quick control screen; the T3i now has a Q/Print button to perform the same function.)

■ **1: Image quality.** Pressing the SET button produces the Shooting 1 menu's Quality menu screen on the color LCD. You can cycle among the various quality options with the up/down and left/right cross keys. Press SET again to lock in your choice.

■ **2: Flash exposure comp.** The SET button summons the flash exposure compensation screen. Use the left/right cross keys to adjust flash exposure plus or minus two stops. If you're using an external flash unit, its internal flash exposure compensation settings override those set from the camera. Press SET to confirm your choice.

■ **3: LCD monitor On/Off.** Assigns to the SET button the same functions as the DISP button. Because the SET button can be accessed with the thumb, you may find it easier to use when turning the LCD monitor on or off.

■ **4: Menu display.** Pressing SET produces the T3i's menu screen on the LCD, with the last menu entry you used highlighted. Press SET again to work with that menu normally, or press the MENU button to cancel and back out of the menus. This setting duplicates the MENU button's function, but some find it easier to locate the SET button with their thumb.

■ **5: ISO speed.** This assigns the SET button the same function as the ISO button. Use it if you'd rather not grope for the ISO button on top of the camera. (On the T1i, this choice was used to disable the SET button function.)

C.Fn IV-11: LCD Display When Power On

Options: Display on, Previous display status

LCD display when power on. Controls the behavior of the LCD when the Rebel T3i is switched on. There are two options:

■ **0: Display on.** When the T3i is powered on, the shooting settings screen will be shown. You can turn this screen on and off by pressing the DISP button. Use this option if you always want the settings screen to be displayed when the camera is turned on.

■ **1: Previous display status.** When the Rebel T3i is turned on, the LCD monitor will display the shooting settings screen if it was turned on when the camera was last powered down. If the screen had been turned off (by pressing the DISP button), it will not be displayed when the T3i is next powered up. Use this option if you frequently turn off the settings screen, and want the camera to "remember" whether the screen was on display when the T3i was last powered down.

Copyright Settings

Options: Display copyright info, Enter author's name, Enter copyright details, Delete copyright information

This setting allows you to enter copyright information that will be embedded in the image file with the other Exif (Exchangeable Image Format) information. It has four choices:

- **Display copyright info.** This shows the current copyright information stored in the camera. If you have not yet entered this data, this menu choice will be grayed out and unavailable.

- **Enter author's name.** Choose this, and a text entry screen will pop up that allows you to enter up to 63 alphanumeric characters and symbols. Press the Q button to choose from among the available text characters, using the cross keys to select, and the SET button to confirm a character. Repeat until the entire text is entered. Press the MENU button to finish, or the DISP button to cancel. The Trash button erases a selected character. (See Figure 4.8.) I recommend saving a lot of time and entering this information using the EOS Utility software when your camera is connected to your computer. The camera-entry method is useful only if you're out in the field and need to change the copyright information for some reason.

- **Enter copyright details.** Produces the same text entry screen. (Use the EOS Utility.)

- **Delete copyright information.** Allows you to delete current copyright information. If you have not yet entered this data, this menu choice will be grayed out and unavailable.

Figure 4.8

Copyright information can be entered manually with this screen or uploaded to your camera with the EOS Utility.

Clear Settings

Options: Clear all camera settings, Clear all custom func., Cancel

This menu choice resets all the settings to their default values. You can choose Clear all camera settings, Clear all custom func. (C.Fn), or Cancel. When you choose Clear all camera settings, regardless of how you've set up your Rebel T3i, it will be adjusted for One-Shot AF mode, automatic AF point selection, Evaluative metering, JPEG Fine Large image quality, automatic ISO, sRGB color mode, automatic white balance, and Standard Picture Style. Any changes you've made to exposure compensation, flash exposure compensation, and white balance will be canceled, and any bracketing for exposure or white balance nullified. Custom white balances and Dust Delete Data will be erased.

The Clear all Custom Func. (C.Fn) choice can be used to clear all camera Custom Functions. Press the SET button, then rotate the left/right cross keys to either Cancel or OK. Press the SET button to confirm. All Custom Functions will be reset to their default 0 values.

Table 4.1 shows the setting defaults after using this menu option.

Table 4.1 Camera Setting Defaults

Shooting Settings	Default Value
AF mode	One-Shot AF
AF point selection	Auto selection
Metering mode	Evaluative
ISO speed	Auto
Drive mode	Single shooting
Exposure compensation/AEB	Canceled
Flash exposure compensation	0
Custom Functions	Unchanged
Image-Recording Settings	**Default Value**
Quality	JPEG Large/Fine
Picture Style	Standard
Auto Lighting Optimizer	Standard
Peripheral illumination correction	Enable/correction data retained
Color space	sRGB
White balance	Auto
Custom white balance	Canceled

Table 4.1 Camera Setting Defaults (continued)

Image-Recording Settings	Default Value
White balance correction	Canceled
WB-BKT	Canceled
File numbering	Continuous
Auto cleaning	Enable
Dust Delete Data	Erased

Live View settings	Default
Live view shooting	Enable
AF mode	Live mode
Grid display	Off
Aspect Ratio	3:2
Metering timer	16 seconds

Camera Settings	Default Value
Auto power off	30 seconds
Beep	Enable
Release shutter without card	Enable
Image Review	2 seconds
Histogram	Brightness
Image jump with Main Dial	10 images
Auto rotate	On/Camera/Display/Computer
LCD brightness	Centered
LCD off/on button	Shutter button
Date/Time	Unchanged
Language	Unchanged
Video system	Unchanged
Feature Guide	Enable
Copyright information	Unchanged
Bass boost	Disable
Control over HDMI	Disable
Eye-Fi transmission	Disable
My Menu settings	Unchanged

Table 4.1 Camera Setting Defaults (continued)

Movie settings	Default
Movie Exposure	Auto
AF mode	Live mode
AF w/shutter button during movie shooting	Disable
Shutter/AE Lock Button	AF/AE Lock
Remote control	Disable
Movie shooting highlight tone priority	Disable
Movie-recording size	1920 × 1080, 30fps
Sound recording	Auto
Metering timer	16 sec.
Grid display	Off
Video snapshot	Disable
Auto Lighting Optimizer	Standard
Custom white balance	Canceled
Exposure compensation	Canceled
Picture Style	Auto

Firmware Version

Options: View version, Update firmware

You can see the current firmware release in use in the menu listing. If you want to update to a new firmware version, insert a memory card containing the binary file, and press the SET button to begin the process.

My Menu

The Canon EOS Rebel T3i has a great feature that allows you to define your own menu, with just the items listed that you want. Remember that the T3i always returns to the last menu and menu entry accessed when you press the MENU button. So you can set up My Menu to include just the items you want, and jump to those items instantly by pressing the MENU button. To create your own My Menu, you have to *register* the menu items you want to include.

Just follow these steps:

1. Press the MENU button and use the left/right cross keys to select the My Menu tab. When you first begin, the personalized menu will be empty except for the My Menu Settings entry. Press the SET button to select it. You'll then see a screen like the one shown in Figure 4.9.

2. Use the up/down cross keys to select Register, then press the SET button.

3. Use the up/down cross keys to scroll down through the continuous list of all menu entries that can be registered to find one you would like to add. Press SET.

4. Confirm your choice by selecting OK in the next screen and pressing SET again.

5. Continue to select up to six menu entries for My Menu.

6. When you're finished, press the MENU button twice to return to the My Menu screen to see your customized menu, which might look like Figure 4.10.

In addition to registering menu items, you can perform other functions at the My Menu settings screen:

- **Changing the order.** Choose Sort to reorder the items in My Menu. Select the menu item to be moved and press the SET button. Press the up/down cross keys to move the item up and down within the menu list. When you've placed it where you'd like it, press the MENU button to lock in your selection and return to the previous screen.

- **Delete/Delete all items.** Use these to remove an individual menu item or all menu items you've registered in My Menu.

Figure 4.9
In the My Menu settings screen you can add menu items, delete them, and specify whether My Menu always pops up when the MENU button is pressed.

Figure 4.10
You can add one to six menu entries to My Menu. Three entries are shown.

■ **Display from My Menu.** As I mentioned earlier, the T3i (almost) always shows the last menu item accessed. That's convenient if you used My Menu last, but if you happen to use another menu, then pressing the MENU button will return to that item instead. If you enable the Display from My Menu option, pressing the MENU button will *always* display My Menu first. You are free to switch to another menu tab if you like, but the next time you press the MENU button, My Menu will come up again. Use this option if you work with My Menu a great deal and make settings with other menu items less frequently.

Movie Settings

The Rebel T3i has one additional "hidden" menu called Movie settings, which appears only when the Mode Dial is set to the Movie position (rotate the Mode Dial as far as it will go in the clockwise direction). You won't be using this menu when shooting still pictures, so I'm going to leave the discussion of its functions for Chapter 6, which discusses the camera's movie-making capabilities in more detail.

Chapter 5

Using the Flash

Your T3i has a flip-up electronic flash unit built in, but you can also use an external flash (or, "strobe" or "Speedlite"), either mounted on the T3i's accessory shoe or used off-camera and linked with a cable or triggered by a slave light (which sets off a flash when it senses the firing of another unit). This chapter deals primarily with using the camera's built-in flash; the options and permutations of working with one or more external flash units are so vast that squeezing more than an overview into a compact book would be impossible. You'll find the equivalent of more than 100 pages of coverage in my full-size book, *David Busch's Canon EOS T3i/600D Guide to Digital SLR Photography.*

Consider using electronic flash:

- **When you need extra light.** Flash provides extra illumination in dark environments where existing light isn't enough for a good exposure, or is too uneven to allow a good exposure even with the camera mounted on a tripod.

- **When you don't need a precise preview of lighting effects.** Although some external units have a modeling flash feature that gives a preview of the strobe's effects, the "modeling" flash may not give you a precise look at what you're going to get. Unless you're using a studio flash with a full-time modeling lamp, electronic flash works best when you are able to visualize its effects in your mind, or don't need a precise preview.

- **When you need to stop action.** The brief duration of electronic flash serves as a very high "shutter speed" when the flash is the main or only source of illumination for the photo. Your T3i's shutter speed may be set for 1/200th second during a flash exposure, but if the flash illumination predominates, the *effective* exposure time will be the 1/1,000th to 1/50,000th second or less duration of the flash, because the flash unit reduces the amount of light released by cutting short the duration of the flash. However, if the ambient light is strong enough, it may produce a secondary, "ghost" exposure, as I'll explain later in this chapter.

■ **When you need flexibility.** Electronic flash's action-freezing power allows you to work without a tripod in the studio (and elsewhere), adding flexibility and speed when choosing angles and positions. Flash units can be easily filtered, and, because the filtration is placed over the light source rather than the lens, you don't need to use high-quality filter material.

■ **When you can use—or counter—flash's relatively shallow "depth-of-light" (the inverse square law).** Electronic flash units don't have the sun's advantage of being located 93 million miles from the subject, and suffer from the effects of their proximity. The *inverse square law* dictates that as a light source's distance increases from the subject, the amount of light reaching the subject falls off proportionately to the square of the distance. In plain English, that means that a flash or lamp that's eight feet away from a subject provides only one-quarter as much illumination as a source that's four feet away (rather than half as much). (See Figure 5.1.) You can *use* this effect to separate subjects located at different distances thanks to the differing amount of illumination each receives. But when you want a larger area blanketed more evenly with illumination, you have to *counter* the effects of the inverse square law with supplemental lighting, slow shutter speeds (which allow ambient light to register along with the flash), or by repositioning your subjects so all are within your flash's depth-of-light coverage.

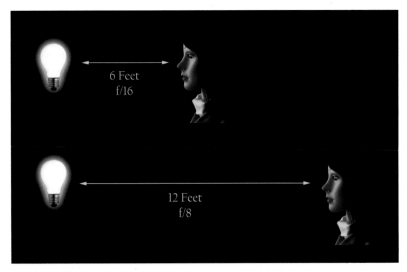

Figure 5.1 A light source that is twice as far away provides only one-quarter as much illumination.

Using the Built-In Flash

The Canon EOS Rebel T3i's built-in flash is a handy accessory because it is available as required, without the need to carry an external flash around with you constantly. This section explains how to use the flip-up flash in the various Basic Zone and Creative Zone modes.

Basic Zone Flash

When the T3i is set to one of the Basic Zone modes (except for Landscape, Sports, or Flash Off modes), the built-in flash will pop up when needed to provide extra illumination in low-light situations, or when your subject matter is backlit and could benefit from some fill flash. The flash doesn't pop up in Landscape mode because the flash doesn't have enough reach to have much effect for pictures of distant vistas in any case; nor does the flash pop up automatically in Sports mode, because you'll often want to use shutter speeds faster than 1/200th second and/or be shooting subjects that are out of flash range. Pop-up flash is disabled in Flash Off mode for obvious reasons. When using the Basic Zone modes other than Creative Auto, the flash can't be popped up manually; it will flip into place only when the T3i decides you need it.

If you happen to be shooting a landscape photo and do want to use flash (say, to add some illumination to a subject that's closer to the camera), or you want flash with your sports photos, or you *don't* want the flash popping up all the time when using one of the other Basic Zone modes, switch to an appropriate Creative Zone mode and use that instead.

Creative Zone Flash

When you're using a Creative Zone mode, you'll have to judge when flash might be useful, and flip it up yourself by pressing the Flash button on the side of the pentaprism. The behavior of the internal flash varies, depending on which Creative Zone mode you're using.

■ **P/A-DEP.** In these modes, the T3i fully automates the exposure process, giving you subtle fill flash effects in daylight, and fully illuminating your subject under dimmer lighting conditions. The camera selects a shutter speed from 1/60th to 1/200th second and sets an appropriate aperture.

■ **Av.** In Aperture-priority mode, you set the aperture as always, and the T3i chooses a shutter speed from 30 seconds to 1/200th second. Use this mode with care, because if the camera detects a dark background, it will use the flash to expose the main subject in the foreground, and then leave the shutter open long enough to allow the background to be exposed correctly, too.

If you're not using an image-stabilized lens, you can end up with blurry ghost images even of non-moving subjects at exposures longer than 1/30th second, and if your camera is not mounted on a tripod, you'll see these blurs at exposures longer than about 1/8th second even if you are using IS.

- **Tv.** When using flash in Tv mode, you set the shutter speed from 30 seconds to 1/200th second, and the T3i will choose the correct aperture for the correct flash exposure. If you accidentally set the shutter speed higher than 1/200th second, the camera will reduce it to 1/200th second when you're using the flash.

- **M.** In Manual mode, you select both shutter speed (30 seconds to 1/200th second) and aperture. The camera will adjust the shutter speed to 1/200th second if you try to use a faster speed with flash. The E-TTL II system will provide the correct amount of exposure for your main subject at the aperture you've chosen (if the subject is within the flash's range, of course).

When using Creative Zone modes (or any Basic Zone mode in which flash is used), if Red-eye reduction is turned on in the Shooting menu (as described in Chapter 3), the red-eye reduction lamp will illuminate for about 1.5 seconds when you press down the shutter release halfway, theoretically causing your subjects' irises to contract (if they are looking toward the camera), and thereby reducing the red-eye effect in your photograph.

Flash Range

The illumination of the T3i's built-in flash varies with distance, focal length, and ISO sensitivity setting.

- **Distance.** The farther away your subject is from the camera, the greater the light fall-off, thanks to the inverse square law discussed earlier. Keep in mind that a subject that's twice as far away receives only one-quarter as much light, which is two f/stops' worth.

- **Focal length.** The built-in flash "covers" only a limited angle of view, which doesn't change, but which is sufficient for most lenses, including the 18-55mm kit lens. With lenses wider than 18mm, however, the frame may not be covered fully, and you'll experience dark areas, especially in the corners. As you zoom in using longer focal lengths, some of the illumination is outside the area of view and is "wasted." (This phenomenon is why some external flash units, such as the 580EX II, "zoom" to match the zoom setting of your lens to concentrate the available flash burst onto the actual subject area.)

- **ISO setting.** The higher the ISO sensitivity, the more photons captured by the sensor. So, doubling the sensitivity from ISO 100 to 200 produces the same effect as, say, opening up your lens from f/8 to f/5.6.

Flash Control Menus

Here's a recap of this multi-level menu entry, described in Chapter 3. It includes five settings for controlling the Canon EOS Rebel T3i's built-in, pop-up electronic flash unit, as well as dedicated Canon Speedlites you can attach to the camera (see Figure 5.2).

Flash Firing

Use this option to enable or disable the built-in or accessory electronic flash in Creative Zone modes. When disabled, the flash cannot fire even if you accidentally elevate it, or have an accessory flash attached and turned on when using Creative Zone modes.

E-TTL II Metering

The second choice in the Flash Control menu allows you to choose the type of exposure metering the T3i uses for electronic flash. You can select the default Evaluative metering, which selectively interprets the 63 metering zones in the viewfinder to intelligently classify the scene for exposure purposes. Alternatively, you can select Average, which melds the information from all the zones together as an average exposure. You might find this mode useful for evenly lit scenes, but, in most cases, exposure won't be exactly right and you may need some flash exposure compensation adjustment.

Built-in Flash Function Setting

There are six choices for this menu option:

■ **Built-in flash.** Your choices here are Normal Firing, Easy Wireless, and Custom Wireless. The first choice is used when you're working with the built-in flash only. Easy Wireless is a long-needed basic wireless flash shooting mode that allows you to quickly set up your T3i to trigger an external

Flash control		External flash func. setting	
Flash firing	Enable	Flash mode	E-TTL II
Built-in flash func. setting		Shutter sync.	1st. curtain
External flash func. setting		FEB	⁻3..2..1..0..1..2.⁺3
External flash C. Fn. setting		Flash exp. comp	⁻2..1..0..1..⁺2
Clear ext. flash C. Fn. set.		E-TTL II meter.	Evaluative
		Zoom	Auto
	MENU ⏎	DISP. Clear Speedlite settings	

Figure 5.2 The Flash Control menu entry has five setting submenus for the built-in flash, plus settings for external units when attached.

flash that is not physically wired to the camera. Custom Wireless is a more fully featured (and potentially fully confusing) wireless option that requires you to make key settings yourself.

■ **Flash Mode.** This entry is available only if you've selected Custom Wireless (above), and allows you to choose from automatic exposure calculation (E-TTL II) or manual flash exposure. Be sure to set this back to Normal firing when through with wireless flash.

■ **Shutter sync.** Available only in Normal Firing mode, you can choose 1st curtain sync, which fires the pre-flash used to calculate the exposure before the shutter opens, followed by the main flash as soon as the shutter is completely open. This is the default mode, and you'll generally perceive the pre-flash and main flash as a single burst. Alternatively, you can select 2nd curtain sync, which fires the pre-flash as soon as the shutter opens, and then triggers the main flash in a second burst at the end of the exposure, just before the shutter starts to close. (If the shutter speed is slow enough, you may clearly see both the pre-flash and main flash as separate bursts of light.) This action allows photographing a blurred trail of light of moving objects with sharp flash exposures at the beginning and the end of the exposure.

If you have an external compatible Speedlite attached, you can also choose Hi-speed sync, which allows you to use shutter speeds faster than 1/200th second, using the External Flash Function Setting menu, described next.

■ **Flash exposure compensation.** If you'd rather adjust flash exposure using a menu than with the ISO/Flash exposure compensation button, you can do that here. Select this option with the SET button, then dial in the amount of flash EV compensation you want using the cross keys. The EV that was in place before you started to make your adjustment is shown as a blue indicator, so you can return to that value quickly. Press SET again to confirm your change, then press the MENU button twice to exit.

■ **Wireless functions.** These choices appear when you've selected Custom Wireless, and include Flash mode, Channel, Firing group, and other options that are used only when you're working in wireless mode to control an external flash. If you've disabled wireless functions, these other options don't appear on the menu.

■ **Clear flash settings.** When the Built-in flash func. setting (or External flash func. setting) screen is shown, you can press the INFO button to produce a screen that allows you to clear all the flash settings.

Ghost Images

The difference between triggering the flash when the shutter just opens, or just when it begins to close might not seem like much. But whether you use 1st curtain sync (the default setting) or 2nd curtain sync (an optional setting) can make a significant difference to your photograph *if the ambient light in your scene also contributes to the image.*

At faster shutter speeds, particularly 1/200th second, there isn't much time for the ambient light to register, unless it is very bright. It's likely that the electronic flash will provide almost all the illumination, so 1st curtain sync or 2nd curtain sync isn't very important. However, at slower shutter speeds, or with very bright ambient light levels, there is a significant difference, particularly if your subject is moving, or the camera isn't steady.

In any of those situations, the ambient light will register as a second image accompanying the flash exposure, and if there is movement (camera or subject), that additional image will not be in the same place as the flash exposure. It will show as a ghost image and, if the movement is significant enough, as a blurred ghost image trailing in front of or behind your subject in the direction of the movement.

As I noted, when you're using 1st curtain sync, the flash's main burst goes off the instant the shutter opens fully (a pre-flash used to measure exposure in auto flash modes fires *before* the shutter opens). This produces an image of the subject on the sensor. Then, the shutter remains open for an additional period (30 seconds to 1/200th second, as I said). If your subject is moving, say, towards the right side of the frame, the ghost image produced by the ambient light will produce a blur on the right side of the original subject image, making it look as if your sharp (flash-produced) image is chasing the ghost. For those of us who grew up with lightning-fast superheroes who always left a ghost trail *behind them*, that looks unnatural (see Figure 5.3).

So, Canon uses 2nd curtain sync to remedy the situation. In that mode, the shutter opens, as before. The shutter remains open for its designated duration, and the ghost image forms. If your subject moves from the left side of the frame to the right side, the ghost will move from left to right, too. *Then*, about 1.5 milliseconds before the second shutter curtain closes, the flash is triggered, producing a nice, sharp flash image *ahead* of the ghost image.

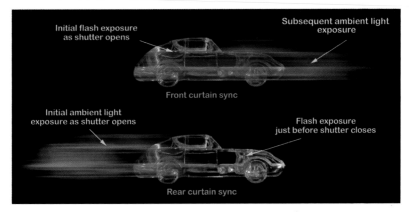

Figure 5.3 1st curtain sync produces an image that trails in front of the flash exposure (top), while 2nd curtain sync creates a more "natural looking" trail behind the flash image.

External Flash Function Setting

This menu is available only when you have a compatible dedicated Canon Speedlite electronic flash attached and switched on. The settings available are shown at right in Figure 5.2. If you press the DISP button while adjusting flash settings, both the changes made to the settings of an attached external flash and to the built-in flash will be cleared.

■ **Flash mode.** This entry allows you to set the flash mode for the external flash, from E-TTL II, Manual flash, MULTI flash, TTL, AutoExFlash, and ManEx flash. The first two are identical to the modes described earlier. The third, MULTI flash, allows stroboscopic/repeating flash effects, and will be described next. The remaining three are optional metering modes available with certain flash units, such as the 580 EX II, and are available for those who might need one of those less sophisticated flash metering systems. TTL measures light bouncing back from your subject through the lens to calculate exposure but, unlike E-TTL II, does not use a pre-flash or intelligent evaluation of the measurements to adjust for different types of scenes. AutoExFlash and ManEx flash don't measure light through the lens at all, but, instead, meter the illumination falling on an external sensor (with an unvarying 20-degree angle of view) that's built into the flash. The former method performs automatic exposure calculation using this information, while the latter provides data you can use for manual flash exposure.

■ **Shutter sync.** As with the T3i's internal flash, you can choose 1st curtain sync, which fires the flash as soon as the shutter is completely open (this is the default mode). Alternatively, you can select 2nd curtain sync, which fires the flash as soon as the shutter opens, and then triggers a second flash at the end of the exposure, just before the shutter starts to close. If a compatible Canon flash, such as the Speedlite 580EX II is attached and turned on, you can also select Hi-speed sync. and shoot using shutter speeds faster than 1/200th second. HSS does not work in wireless mode.

■ **FEB.** Flash Exposure Bracketing (FEB) operates similarly to ordinary exposure bracketing, providing a series of different exposures to improve your chances of getting the exact right exposure, or to provide alternative renditions for creative purposes.

■ **Zoom.** Some flash units can vary their coverage to better match the field of view of your lens at a particular focal length. You can allow the external flash to zoom automatically, based on information provided, or manually, using a zoom button on the flash itself. This setting is disabled when using a flash like the Canon 270EX II, which does not have zooming capability. You can select Auto, in which case the camera will tell the flash unit the focal length of the lens, or choose individual focal lengths from 24mm to 105mm.

■ **Wireless func.** These functions are available when using wireless flash. This setting allows you to enable or disable wireless functions.

■ **Master flash.** You can enable or disable use of some compatible external flash units as the master controller for the other wireless flashes. When set to enable, the attached external flash is used as the master; when disabled, the external flash becomes a slave unit triggered by the T3i's built-in flash.

■ **Channel.** All flashes used wirelessly can communicate on one of four channels. This setting allows you to choose which channel is used. Channels are especially helpful when you're working around other Canon photographers; each can select a different channel so one photographer's flash units don't trigger those of another photographer.

■ **Firing Group.** Multiple flash units can be assigned to a group. This choice allows specifying which groups are triggered, A/B, A/B plus C, or All.

■ **Flash exposure compensation.** You can adjust flash exposure for external flash using a menu here. Select this option with the SET button, then dial in the amount of flash EV compensation you want using the cross keys. The EV that was in place before you started to make your adjustment is shown as a blue indicator, so you can return to that value quickly. Press SET again to confirm your change, then press the MENU button twice to exit.

- **A:B fire ratio.** Sets the proportionate outputs of Groups A and B, along with Channels, Firing Groups, and the other Wireless flash features.
- **Group C exposure compensation.** You can set flash exposure compensation separately for Group C flashes.

External Flash Custom Function Setting

Many external Speedlites from Canon include their own list of Custom Functions, which can be used to specify things like flash metering mode and flash bracketing sequences, as well as more sophisticated features, such as modeling light/flash (if available), use of external power sources (if attached), and functions of any slave unit attached to the external flash. This menu entry allows you to set an external flash unit's Custom Functions from your T3i's menu.

Clear External Flash Custom Function Setting

This entry allows you to zero-out any changes you've made to your external flash's Custom Functions, and return them to their factory default settings.

Using FE Lock and Flash Exposure Compensation

If you want to lock flash exposure for a subject that is not centered in the frame, you can use the FE lock button (*) to lock in a specific flash exposure, although the procedure is made tricky because of the sequence of steps that the T3i requires. Depress and hold the shutter button halfway to lock in focus, then center the viewfinder on the subject you want to correctly expose, and press the * button. (It's quite difficult to hold the camera, hold the shutter release down halfway, and then press the * button. To make things more interesting, Canon also recommends that you look into the viewfinder to make sure the flash-ready icon is still lit while doing this.) If you're successful, the pre-flash fires and calculates exposure, displaying the FEL (flash exposure lock) message in the viewfinder. Then, recompose your photo and press the shutter down the rest of the way to take the photo.

You can also manually add or subtract exposure to the flash exposure calculated by the T3i. Just select the Choose the Flash Control entry in Shooting 1 menu, choose Built-in Flash, then the Built-in Flash function, and choose Select Flash Exp. Comp. Then use the left/right cross keys to enter flash exposure compensation plus or minus two f/stops. The exposure index scale on the LCD and in the viewfinder will indicate the change you've made, and a flash exposure compensation icon will appear to warn you that an adjustment has been made. As with non-flash exposure compensation, the compensation you make remains in

effect for the pictures that follow, and even when you've turned the camera off, remember to cancel the flash exposure compensation adjustment by reversing the steps used to set it when you're done using it.

Using External Electronic Flash

Canon offers a broad range of accessory electronic flash units for the EOS T3i. They can be mounted to the flash accessory shoe, or used off-camera with a dedicated cord that plugs into the flash shoe to maintain full communications with the camera for all special features. (Non-dedicated flash units, such as studio flash, can be connected using a PC terminal adapter slipped into the flash shoe.) They range from the Speedlite 580EX II, which can correctly expose subjects up to 17 feet away at f/11 and ISO 100, to the 270EX, which is good out to 8 feet at f/11 and ISO 100. (You'll get greater ranges at even higher ISO settings, of course.) There are also two electronic flash units specifically for specialized close-up flash photography.

Speedlite 580EX II

This flagship of the Canon accessory flash line is the most powerful unit the company offers, with a GN of 190, and a manual/automatic zoom flash head that covers the full frame of lenses from 24mm wide angle to 105mm telephoto. (There's a flip-down wide-angle diffuser that spreads the flash to cover a 14mm lens' field of view, too.) All angle specifications given by Canon refer to full-frame sensors, but this flash unit automatically converts its field of view coverage to accommodate the crop factor if you also use it on a cropped sensor camera like the EOS 7D. (Handy if you own both.) Compared to the 580 EX it replaces, the Mark II model recycles (inaudibly—no more hum!) 20 percent faster, and has improved dust- and water-resistance so you can use it in harsher environments.

The unit offers full-swivel, 180-degrees in either direction, and has its own built-in AF-assist beam and an exposure system that's compatible with the eleven focus points of the T3i. Powered by economical AA-size batteries, the unit recycles in 0.1 to 6 seconds, and can squeeze 100 to 700 flashes from a set of batteries.

The 580EX II automatically communicates white balance information to your camera, allowing it to adjust WB to match the flash output. You can even simulate a modeling light effect: When you press the depth-of-field preview button on the T3i, the 580EX II emits a one-second burst of light that allows you to

judge the flash effect. If you're using multiple flash units with Canon's wireless E-TTL system, this model can serve as a master flash that controls the slave units you've set up (more about this later) or function as a slave itself.

It's easy to access all the features of this unit, because it has a large backlit LCD panel on the back that provides information about all flash settings. There are 14 Custom Functions that can be controlled from the flash or camera, numbered from 00 to 14. These functions are (the first setting is the default value):

C.Fn-00	Distance indicator display (Meters/Feet)
C.Fn-01	Auto power off (Enabled/Disabled)
C.Fn-02	Modeling flash (Enabled-DOF preview button/Enabled-Test firing button/Enabled-Both buttons/Disabled)
C.Fn-03	FEB Flash exposure bracketing auto cancel (Enabled/Disabled)
C.Fn-04	FEB Flash Exposure Bracketing Sequence (Metered > Decreased > Increased Exposure/Decreased > Metered > Increased Exposure)
C.Fn-05	Flash metering mode (E-TTL/II-E-TTL/TTL/External metering: Auto/External metering: Manual)
C.Fn-06	Quickflash with continuous shot (Disabled/Enabled)
C.Fn-07	Test firing with autoflash (1/32/Full power)
C.Fn-08	AF-assist beam firing (Enabled/Disabled)
C.Fn-09	Auto zoom adjusted for image/sensor size (Enabled/Disabled)
C.Fn-10	Slave auto power off timer (60 minutes/10 minutes)
C.Fn-11	Cancellation of slave unit auto power off by master unit (Within 8 Hours/Within 1 Hour)
C.Fn-12	Flash recycling on external power (Use internal and external power/Use only external power)
C.Fn-13	Flash exposure metering setting button (Speedlite button and dial/Speedlite dial only)

Speedlite 430EX II

This less pricey electronic flash has a GN of 141, with automatic and manual zoom coverage from 24mm to 105mm, and the same wide-angle pullout panel found on the 580EX II that covers the area of a 14mm lens on a full-frame camera, and automatic conversion to the cropped frame area of the T3i and other

1.6X crop Canon dSLRs. The 430EX II also communicates white balance infor-mation with the camera, and has its own AF-assist beam. Compatible with Canon's wireless E-TTL system, it makes a good slave unit, but cannot serve as a master flash. It, too, uses AA batteries, and offers recycle times of 0.1 to 3.7 seconds for 200 to 1,400 flashes, depending on subject distance.

Speedlite 320EX

One of two new flash units (with the Speedlite 270EX II, described next) intro-duced early in 2011, this $249 flash has a GN of 105. Lightweight and more pocket-sized than the 430 EX II or 580 EX II, this bounceable (both horizon-tally and vertically) flash has some interesting features, including a built-in LED video light that can be used for shooting movies with the T3i, or as a modeling light or even AF-assist beam when shooting with Live View. Canon says that this efficient LED light can provide up to four hours of illumination with a set of AA batteries. It can be used as a wireless slave unit, and has a new flash release function that allows the shutter to be triggered remotely with a two-second delay.

Speedlite 270EX II

This $170 ultra-compact unit is Canon's entry-level Speedlite, and suitable for T3i owners who want a simple strobe for occasional use, without sacrificing the ability to operate it as a wireless slave unit. With a GN of 89, it provides a little extra pop for fill flash applications. It has vertical bounce capabilities of up to 90 degrees, and can be switched between Tele modes to Normal (28mm full-frame coverage) at a reduced guide number of 72.

The 270EX II functions as a wireless slave unit triggered by any Canon EOS unit or flash (such as the 580 EX II) with a Master function. It also has the new flash release function with a two-second delay that lets you reposition the flash. There's a built-in AF-assist beam, and this 5.5-ounce, $2.6 \times 2.6 \times 3$-inch unit is powered by just two AA-size batteries.

Elements of Wireless Flash

Complete instruction in using the T3i wireless flash capabilities is beyond the scope of this Compact Field Guide (even a basic description would require more than half the pages in this book), but I'm going to provide a few checklists you can use as reminders once you've mastered the basics. You'll find more detailed instructions in the manual furnished with your external flash.

Here are some of the key concepts to electronic flash and wireless flash that I'll be describing in this chapter. Learn what these are, and you'll have gone a long way towards understanding how to use wireless flash. You need to understand the various combinations of flashes that can be used, how they can be controlled individually and together, and why you might want to use multiple and off-camera flash units. I'm going to address all these points in this section.

Flash Combinations

Your T3i's built-in flash can be used alone, or in combination with other, external flash units.

- **Built-in flash used alone.** Your built-in flash can function as the only flash illumination used to take a picture.

- **Built-in flash used simultaneously with off-camera flash.** You can use the off-camera flash as a *main light* and supply *fill light* from the built-in flash to produce interesting effects and pleasing portraits.

- **Built-in flash used as a trigger only for off-camera flash.** Use the T3i's built-in wireless flash controller to command single or multiple Speedlites for studio-like lighting effects, without having the pop-up flash contribute to the exposure itself.

Controlling Flash Units

There are multiple ways of controlling flash units, both through direct or wired connections and wirelessly.

- **Direct connection.** The built-in flash is triggered electronically when a picture is taken. External flash units can also be controlled directly, either by plugging them into the accessory shoe on top of the camera, or by linking them to a camera with a dedicated flash cord that in turn attaches to the accessory hot shoe. When used in these modes, the camera has full communication with the flash, which can receive information about zoom lens

position, correct exposure required, and the signals required to fire the flash. There also exist accessory shoe adapters that provide a PC/X connection, allowing non-dedicated strobes, such as studio flash units to be fired by the camera. These connections are "dumb" and convey no information other than the signal to fire.

■ **Dedicated wireless optical signals.** In this mode, external flash units communicate with the camera through a pre-flash, which is used to measure exposure prior to the "real" flash burst an instant later, providing camera/flash communication similar to that of a direct connection.

■ **Dedicated wireless infrared signals.** Some devices, such as the accessory-shoe-mounted Canon ST-E2 Speedlite Transmitter, can communicate with dedicated flash units through infrared signals. Although the ST-E2 costs about $250, it's still less expensive than using a unit like the 580EX II as a master controller, particularly when use of the on-camera flash as a master is not desired.

■ **Third-party IR and radio transmitters.** Some excellent wireless flash controllers that use IR or radio signals to operate external flash units are available from sources like PocketWizard and RadioPopper.

■ **Optical slave units.** A relatively low-tech/low-versatility option is to use optical slave units that trigger the off-camera flash units when they detect the firing of the main flash. Slave triggers are inexpensive, but dumb: they don't allow making any adjustments to the external flash units, and are not compatible with the T3i's E-TTL II exposure system. Moreover, you should make sure that the slave trigger responds to the *main* flash burst only, rather than a pre-flash, using a so-called *digital* mode. Otherwise, your slave units will fire before the main flash, and not contribute to the exposure.

Key Wireless Concepts

There are three key concepts you must understand before jumping into wireless flash photography: Channels, Groups, and Flash Ratios. Here is an explanation of each:

■ **Channel controls.** Canon's wireless flash system offers users the ability to determine on which of the possible channels the flash units can communicate. The channels are numbered 1, 2, 3, and 4, and each flash must be assigned to one of them. Each of the flash units you are working with should be assigned to the *same* channel, because the slave Speedlites will respond *only* to a master flash that is on the same channel.

■ **Groups.** Canon's wireless flash system lets you designate multiple flash units in separate groups (as many as three groups with the T3i's built-in controller), labeled A, B, and C. All the flash units in all the groups use the same *channel* and all respond to the same master controller, but you can set the output levels of each group separately.

■ **Flash ratios.** This ability to control the output of one flash (or set of flashes) compared to another flash or set allows you to produce lighting *ratios*. You can control the power of multiple off-camera Speedlites to adjust each unit's relative contribution to the image, for more dramatic portraits and other effects.

Wireless Flash Made Easy

The EOS T3i has two wireless flash modes, Easy Wireless Flash Shooting and Custom Wireless Flash Shooting. I'm going to introduce you to the Easy mode. We're going to begin by assuming that you want to use the T3i's built-in flash as the master controller flash. If that's the case, you need to follow these steps with your external flash units first:

1. **Set the wireless Speedlite to slave mode.** The first step is to set the off-camera flash to slave mode. The procedure differs for each individual flash model. For the 580EX II, press the Zoom button for two seconds until the display flashes, then rotate the control dial on the flash until the Slave indicator blinks on the LCD. Press the control dial's center button to confirm your choice.

2. **Assign a Channel.** All units must use the same Channel. The default Channel is 1. If you need to change to a different communications channel, do so using the instructions for your particular flash unit. With the 580EX II, press the Zoom button several times until the CH indicator flashes. Then rotate the control dial on the flash until the channel you want appears on the LCD. Press the control dial center button to confirm your choice.

3. **Assign slave to a group.** If you want to use a flash ratio to adjust the output of some slave units separately, you'll want to assign the slave flash to a group, either Group A (the default) or Group B. All units within a particular group fire at the same proportionate level. And remember that all flash units on a particular channel are controlled by the same master flash, regardless of the group they belong to. Set the group according to the instructions for your particular flash. For the 580EX II, press the Zoom button until the A flashes on the LCD. Then rotate the control dial on the flash to choose B. Press the control dial center button to confirm your choice.

4. **Position the off-camera flash units, with the Speedlite's wireless sensor facing the camera/master flash.** Indoors, you can position the external flash up to 33 feet from the master unit; outdoors, keep the distance to 23 feet or less.

Easy Wireless Flash Shooting

Wireless flash is a breeze if you're using your camera's built-in flash as the master, and one external flash as the slave. Just follow these steps:

1. **Using the built-in flash as a wireless flash controller.** Start by using a Creative Zone mode and popping up the camera's built-in flash. You can use this flash in conjunction with your remote, off-camera strobes (adding some illumination to your photos), or just to control them (with no illumination from your pop-up flash contributing to the exposure). The built-in flash needs to be in the up position to use the T3i's wireless flash controller either way.

2. **Enable internal flash.** Press the MENU button and navigate to the Shooting 1 menu. Choose the Flash Control entry and press the SET button. This brings up the Flash Control menu. Press the SET button to enter the Flash Control menu. Next, select the Flash Firing setting and set the camera to Enable. This activates the built-in flash, which makes wireless flash control with the T3i possible.

3. **Confirm/Enable E-TTL II exposure.** Although you can use wireless flash techniques and manual flash exposure, you're better off learning to use wireless features with the EOS T3i set to automatic exposure. So, from the Flash Control menu, choose E-TTL II metering and select Evaluative exposure.

4. **Enable wireless functions.** Next, choose Built-in Flash Func. and select EasyWireless from the Built-in Flash entry. Press MENU to exit.

5. **Choose a channel.** Scroll down to Channel, press SET and select the channel you want to use (generally that will be Channel 1). Press MENU to exit.

6. **Take photos.** You're all set! You can now take photos wirelessly. Note, that using the settings you've applied, if you disable the built-in flash from firing, it will still trigger the slave unit(s), but, under most conditions its controlling burst won't contribute to the exposure.

7. **Exit wireless mode.** When you're finished using wireless flash, navigate to the Built-in Flash Func. setting in the Flash Control menu and select Normal Firing. Wireless flash is deactivated. This is important because you won't get normal flash pictures unless you do choose Normal Firing again.

If you want to use more than one slave unit, all additional units using the same communications channel will fire at once, regardless of the slave ID (Group) assignment.

Chapter 6

Shooting Movies with Live View

Live View and shooting movies with the T3i go hand in hand: you need to activate Live View to display the current scene as viewed on the lens on the LCD. Thereafter, you can take still photos by pressing the shutter release button, or activate Movie mode and shoot video. While capturing movies, you can still press the shutter release and take a still photo. This chapter tells you how to use Live View first, and then explains the movie shooting options.

Enabling Live View

You need to take some steps before using Live View or shooting movies. This workflow prevents you from accidentally using Live View when you don't mean to, thus potentially losing a shot, and it also helps ensure that you've made all the settings necessary to successfully use the feature efficiently. Here are the steps to follow:

1. **Choose a shooting mode.** Live View works with any exposure mode, including Scene Intelligent Auto and Creative Auto. You can even switch from one Basic Zone mode to another or from one Creative Zone mode to another while Live View is activated. (If you change from Basic to Creative, or vice versa while Live View is on, it will be deactivated and must be restarted.)

2. **Enable Live View.** You'll need to activate Live View by choosing Live View Shoot. setting from the Shooting 4 menu (when the Mode Dial is set to a Creative Zone mode; if you're using a Basic Zone mode, an abbreviated list of Live View options is found in the Shooting 2 menu). Press SET and use the up/down cross keys to select Enable and press the SET button again to exit.

> **TIP**
>
> Note that even if you've disabled Live View, you can still set the Mode Dial to Movie and shoot video.

3. **Choose other Live View functions.** Select from the other Live View functions in the Shooting 4 menu (described next), then press the MENU button to exit from the Live View function settings menu. Make sure you're using a Creative Zone mode if you want to view the full array of Live View function options.

4. **Specify Movie or Live View shooting.** Rotate the Mode Dial to the Movie position if you want to shoot video instead of stills.

5. **Activate Live View.** Press the Start/Stop button on the right side of the viewfinder to begin or end Live View, or to begin/end video capture.

There are five choices in the Live View menu, shown in Figure 6.1. Only the first three choices, listed below, found in the Shooting 2 menu, are available when using a Basic Zone mode. They include:

■ **Live View shoot.** Enable/disable Live View shooting here. As I mentioned, disabling Live View does not effect movie shooting, which is activated by rotating the Mode Dial to the Movie position.

■ **Autofocus mode (Quick mode, Live mode, Live "Face Detection" mode).** This option, explained next, lets you choose between Phase Detection, Contrast Detection, and Contrast Detection with "Face" Recognition.

■ **Grid display (Off, Grid 1, Grid 2).** Overlays Grid 1, a "rule of thirds" grid, on the screen to help you compose your image and align vertical and horizontal lines; or Grid 2, which consists of four rows of six boxes, which allow finer control over placement of images in your frame.

■ **Aspect ratio (3:2, 4:3, 16:9, or 1:1).** Selecting proportions other than the 3:2/18-megapixel default results in a cropped image. At the Large or RAW size setting, you end up with images that measure 4608 × 3456 pixels/16 MP (4:3 ratio); 5184 × 2912 pixels/15.1 MP (16:9 ratio); and 3456 × 3456 pixels/11.9 MP (1:1 ratio). At Medium (M), Small 1 (S1), Small 2 (S2), and Small 3 (S3), the images are proportionately smaller. This choice is not available when using a Basic Zone mode.

■ **Metering timer (4 sec. to 30 min.).** This option allows you to specify how long the T3i's metering system will remain active before switching off. Tap the shutter release to start the timer again after it switches off. This choice is not available when using a Basic Zone mode.

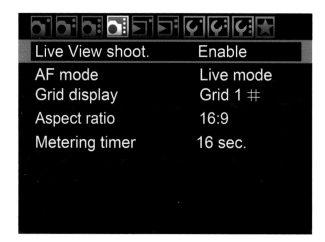

Figure 6.1
You can choose grids, metering timeout, and autofocus mode when using Live View.

Once you've enabled Live View, you can continue taking pictures normally through the T3i's viewfinder. When you're ready to activate Live View, press the Stop/Start button on the back of the camera, to the immediate right of the viewfinder window (and marked with a red dot). The mirror will flip up, and the sensor image will appear on the LCD.

Focusing in Live View

Press the shutter button halfway to activate autofocus using the currently set Live View autofocus mode. Those modes are Live mode, Live "Face Detection" mode, and Quick mode. You can also use manual focus. I'll describe each of these separately.

Select the focus mode for Live View from the Live View entries in the Shooting 4 menu, described earlier. You can also change focus mode while using Live View by pressing the Q button, highlighting the focus options with the cross keys (it's at the top right of the column, as you see in Figure 6.2). Then press the SET button and use the left/right cross keys to choose one of the following three focus modes. Press SET again to confirm your choice.

Live Mode

This mode uses Contrast Detection evaluating the relative sharpness of the image as it appears on the sensor to determine focus. This method is less precise, and usually takes longer than Quick mode. To autofocus using Live mode, follow these steps:

1. **Set lens to autofocus.** Make sure the focus switch on the lens is set to AF.
2. **Activate Live View.** Press the Start/Stop button.

3. **Choose AF point.** Use the cross keys to move the AF point anywhere you like on the screen, except for the edges. Press the Trash button to return the AF point to the center of the screen.

4. **Select subject.** Compose the image on the LCD so the selected focus point is on the subject.

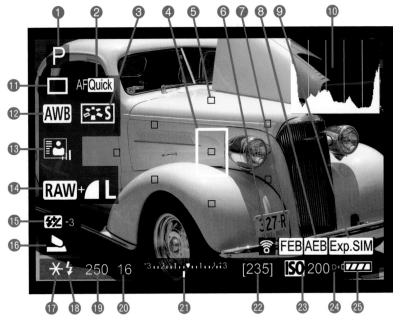

❶ *Shooting mode*	❾ *Exposure simulation*	⑱ *Flash ready*
❷ *AF mode*	❿ *Histogram*	⑲ *Shutter speed*
❸ *Picture Style*	⓫ *Drive mode*	⑳ *Aperture*
❹ *Magnifying frame*	⓬ *White balance*	㉑ *Exposure level*
❺ *AF-point (Quick mode)*	⓭ *Auto Lighting*	*indicator/AEB*
❻ *Eye-Fi card*	*Optimizer*	*bracketing range*
transmission status	⓮ *Image recording quality*	㉒ *Shots remaining*
❼ *Flash exposure*	⓯ *Flash compensation*	㉓ *ISO speed*
bracketing	⓰ *Built-in flash function*	㉔ *Highlight Tone Priority*
❽ *Autoexposure bracketing*	⓱ *AE lock*	㉕ *Battery check*

Figure 6.2 Press the INFO button to increase or decrease the amount of information shown on the LCD in Live View mode.

5. **Press and hold the shutter button halfway.** When focus is achieved, the AF point turns green, and you'll hear a beep if the sound has been turned on in the Shooting 1 menu. If the T3i is unable to focus, the AF point turns orange instead.

6. **Take picture.** Press the shutter release all the way down to take the picture.

Live (Face Detection) Mode

This mode also uses Contrast Detection, using the relative sharpness of the image as it appears on the sensor to determine focus. The T3i will search the frame for a human face and attempt to focus on the face. Like Live mode, this method is less precise, and usually takes longer than Quick mode. To autofocus using Live (Face Detection) mode, follow these steps:

1. **Set lens to autofocus.** Make sure the focus switch on the lens is set to AF.

2. **Activate Live View.** Press the Start/Stop button.

3. **Face detection.** If you've selected Face Detection using the AF button or quick control screen, a frame will appear around a face found in the image. (See Figure 6.3.) (You can press the Zoom In button on the upper-right back of the camera to magnify the area of the image inside the magnify frame.) If more than one face is found, a frame with notches that look like "ears" appears. In that case, use the cross keys to move the frame to the face you want to use for focus. If no face is detected, the AF point will be displayed and focus will be locked into the center.

Figure 6.3
The T3i can detect faces during autofocus.

4. **Troubleshoot (if necessary).** If you experience problems in Live (Face Detection) mode, press down on the AF button or use the quick control screen to toggle between modes. Face Detection is far from perfect. The AF system may fail to find a face if the person's visage is too large/small or light/dark in the frame, tilted, or located near an edge of the picture. It may classify a non-face as a face. If you switch to Live mode, you can always select another AF point and press the cross keys button again to toggle back to Live (Face Detection) mode.

5. **Press and hold the shutter release halfway.** When focus is achieved, the AF point turns green, and you'll hear a beep. If the T3i is unable to focus, the AF point turns orange instead.

6. **Take picture.** Press the shutter release all the way down to take the picture.

Quick Mode

This mode uses Phase Detection. It temporarily interrupts Live View mode to allow the EOS T3i to focus the same AF sensor used when you focus through the viewfinder. Because the step takes a second or so, you may get better results using this autofocus mode when the camera is mounted on a tripod. If you hand-hold the T3i, you may displace the point of focus achieved by the autofocus system. It also simplifies the operation if you use One-Shot focus and center the focus point. You can use AI Servo and Automatic or Manual focus point selection, but if the focus point doesn't coincide with the subject you want to focus on, you'll end up with an out-of-focus image. Just follow these steps.

1. **Set lens to autofocus.** Make sure the focus switch on the lens is set to AF.

2. **Activate Live View.** Press the Start/Stop button.

3. **Choose AF point.** Use the cross keys to move the active AF focus point around on the screen.

4. **Select subject.** Compose the image on the LCD so the selected focus point is on the subject.

5. **Press and hold the shutter release halfway.** The LCD will blank as the mirror flips down, reflecting the view of the subject to the Phase Detection AF sensor.

6. **Wait for focus.** When the T3i is able to lock in focus using Phase Detection, a beep (if activated) will sound. If you are hand-holding the T3i, you may hear several beeps as the AF system focuses and refocuses with each camera movement. Then, the mirror will flip back up, and the Live View image reappears. The AF focus point will be highlighted in green on the LCD.

7. **Take picture.** Press the shutter release all the way down to take the picture. (You can't take a photo while Quick mode AF is in process, until the mirror flips back up.)

Manual Mode

Focusing manually on an LCD screen isn't as difficult as you might think, but Canon has made the process even easier by providing a magnified view. Just follow these steps to focus manually.

1. **Set lens to manual focus.** Make sure the focus switch on the lens is set to MF.

2. **Move magnifying frame.** When Live View is active, use the cross keys to move the focus frame that's superimposed on the screen to the location where you want to focus. You can press the cross keys to center the focus frame in the middle of the screen.

3. **Press the Zoom In button.** The area of the image inside the focus frame will be magnified 5X. (See Figure 6.4.) Press the Zoom In button again to increase the magnification to 10X. A third press will return you to the full-frame view. The enlarged area is artificially sharpened to make it easier for you to see the contrast changes, and simplify focusing. When zoomed in, press the shutter release halfway and the current shutter speed and aperture are shown in orange. If no information at all appears, press the INFO button.

4. **Focus manually.** Use the focus ring on the lens to focus the image. When you're satisfied, you can zoom back out by pressing the Zoom In button to return to normal view.

Figure 6.4 You can manually focus the center area, which can be zoomed in 5X or 10X.

Shooting Movies

The Canon EOS Rebel T3i can shoot full HDTV movies with monaural sound (or stereo sound if you plug in an external microphone) at 1920 × 1080 resolution. You'll want to keep the following things in mind before you start:

- **Choose your resolution.** The T3i can capture movies in Full High Definition (1920 × 1080 pixel) resolution, Standard High Definition (1280 × 720 resolution), and a 640 × 480 cropped resolution that provides a 7x telephoto effect. I'll show you how to specify resolution in the next section.

- **You can still shoot stills.** Press the shutter release all the way down at any time while filming movies in order to capture a still photo. The T3i will use the Image Quality settings you specify in the Shooting 1 menu, operate only in Single shooting drive mode (continuous shooting or self-timer delays are not possible), and flash is disabled. You can also extract a 2MP, 1MP, or .3MP image from your movie clips using ZoomBrowser software. Still photos are stored as separate files.

- **Use the right card.** You'll want to use an SD Class 6 memory card or better to store your clips; slower cards may not work properly. Choose a memory card with at least 4GB capacity (8GB or 16GB are even better). If the card you are working with is too slow, a five-level thermometer-like "buffer" indicator may appear at the right side of the LCD, showing the status of your camera's internal memory. If the indicator reaches the top level because the buffer is full, movie shooting will stop automatically.

- **Use a fully charged battery.** Canon says that a fresh battery will allow about one hour of filming at normal (non-Winter) temperatures.

- **Image stabilizer uses extra power.** If your lens has an image stabilizer, it will operate at all times (not just when the shutter button is pressed halfway, which is the case with still photography) and use a considerable amount of power, reducing battery life. You can switch the IS feature off to conserve power. Mount your camera on a tripod, and you don't need IS anyway.

- **Silent running.** You can connect your T3i to a television or video monitor while shooting movies, and see the video portion on the bigger screen as you shoot. But, the sound will not play (that's a good idea, because, otherwise, you could likely get a screeching feedback loop of sound going). However the sound will be recorded properly and will magically appear during playback once shooting has concluded.

MOVIE TIME

I've standardized on 16GB SDHC cards when I'm shooting movies; these cards will give you 49 minutes of recording at 1920 × 1080 Full HD resolution. (Figure 330MB per minute of capture.) A 4GB card, in contrast, offers just 12 minutes of shooting at the Full HD setting.

Movie Settings

Two pages of Movie Settings menus can be summoned by the MENU button only when the T3i has been set to Movie mode (turn the Mode Dial as far as it will go in the clockwise direction). The five settings on the Movie 1 menu (see Figure 6.5) include:

- **Movie exposure.** Leave this on Auto most of the time. Change to Manual if you'd like to select ISO sensitivity, shutter speed, and aperture. Choosing the ISO setting yourself can be useful when you deliberately want to create a grainy/noisy look as a special effect. Using a higher shutter speed can improve the sharpness of action shots, and having control over the f/stop used can be particularly effective when shooting movies using selective focus techniques (either a large aperture to blur the background, or a small aperture to increase depth-of-field and bring large ranges of subject matter into relatively sharp focus).

Figure 6.5
The Movie Settings 1 menu has six entries.

- **AF mode (Quick mode, Live mode, Live "Face Detection" mode).** This option, explained earlier in the Live View section, lets you choose between Phase Detection, Contrast Detection, and Contrast Detection with "Face" recognition. In movie modes, none of these autofocus modes will track a moving subject.

- **AF w/shutter button during movie recording.** You can choose Enable (to allow refocusing during movie shooting) or Disable to prevent it. Refocusing after you've begun capturing a movie clip can be a good thing or a bad thing, so you want to be able to control when it happens. If you select Enable, then you can refocus during capture by pressing the shutter button. Refocusing will take place *only* when you press the shutter button; the T3i is not able to refocus continually as you shoot.

- **Shutter/AE lock button.** Use this choice to specify what happens when you press the shutter release halfway, or use the AE lock button. Your options are shown in Table 6.1.

Table 6.1 Shutter/AE Lock Button Functions

Option	Shutter release half-press	AE lock button function	Purpose
AF/AE lock	Activates autofocus	Locks exposure	Autofocus and lock exposure separately; normal operation.
AE lock/AF	Locks exposure	Activates autofocus	Lock exposure, then AF after reframing.
AF/AF lock, No AE lock	Activates autofocus	Hold while taking a still photo to shoot at current AF setting	Avoid refocusing when taking a still while shooting a movie.
AE/AF, No AE lock	Meters but does not lock exposure	Activates autofocus	Exposure metering continues after shutter is half-pressed; initiate autofocus when desired.

■ **Remote control.** Enable or disable use of the Wireless Remote Controller RC-6 to start and stop movie shooting. The controller's transmitter button can be used in either of two modes. Slide the switch on the back of the RC-6 up to the 2 position to stop and start movie shooting. Slide it down to the solid circle position and press the transmitter to take a still photo instead.

■ **Movie recording Highlight Tone Priority.** Choose Enable to improve the detail in highlights in your movie clips, say, when shooting under high contrast lighting conditions. Use Disable if you'd like to keep the standard tonal range, which is optimized for middle gray tones. If you enable this feature, then the Auto Lighting Optimizer (discussed in Chapter 8) is disabled, and your ISO speed range is limited to ISO 200-6400.

The five settings on the Movie 2 menu (see Figure 6.6) include:

■ **Movie rec. size.** Choose 1920 × 1080 (Full HD) at 30 or 24 fps; 1280 × 720 (HD) at 60 fps; or 640 × 480 pixel (Standard resolution) at 60 fps. The frame rates are for NTSC television mode; for the PAL system, the camera will substitute 50 fps for 60 fps, and 25 fps for 30 fps. (The motion picture standard, 24 fps, remains constant.)

Single movie clips can be no more than 4GB in size, and shooting will stop automatically at that point. So, the maximum *length* of your videos is determined by the resolution you choose. At either HD setting, your movie will max out at about 12 minutes for a single clip. With either of the 640 × 480-pixel settings, you can shoot about 24 minutes continuously. The number of multiple clips you can fit on a single memory card depends on the size

Figure 6.6
The Movie 2 menu has five entries.

of the card. You can record about 44 minutes of video/sound (in 12-minute max clips) on a 16GB memory card in either HD format, or 92 minutes (in maximum 29-minute, 50-second clips) in 640 × 480-pixel format.

- **Sound recording.** Choose Auto, Manual, or Disable; plus enable or disable wind filter,

 - **Auto.** The T3i sets the audio level for you.

 - **Manual.** Choose from 64 different sound levels. Select Rec Level and use the cross keys while viewing the decibel meter at the bottom of the screen to choose a level that averages −12 dB for the loudest sounds.

 - **Disable.** Shoot silently, and add voice over, narration, music, or other sound later in your movie editing software.

 You can use your T3i's built-in monaural microphone or plug in a stereo microphone into the 3.5mm jack on the side of the camera. An external microphone is a good idea because the built-in microphone can easily pick up camera operation, such as the autofocus motor in a lens.

 - **Wind filter.** Enable to reduce the effects of wind noise on the microphone. This also reduces low tones in our sound recording. If wind is not a problem, you'll get better quality audio with this option disabled. Even better is to use an external microphone with a physical wind shield.

WHAT FRAME RATE?

Frame rates available include 24, 25, 30, 50, and 60 frames per second. Which to use? The difference lies in the two "worlds" of motion images, film and video. The standard frame rate for motion picture film is 24 fps, while the video rate, at least in the United States, Japan, and those other places using the NTSC standard is 30 fps (actually 60 interlaced *fields* per second, which is why we can choose either 30 frames/fields per second or 60 frames/fields per second). Computer editing software can handle either type, and convert between them. The choice between 24 fps and 30 fps is determined by what you plan to do with your video.

The short explanation is that shooting at 24 fps gives your movie a "film" look, excellent for showing fine detail. However, if your clip has moving subjects, or you pan the camera, 24 fps can produce a jerky effect called "judder." A 30 or 60 fps rate produces a home-video look that some feel is less desirable, but which is smoother and less jittery when displayed on an electronic monitor. I suggest you try both and use the frame rate that best suits your tastes and video editing software.

- **Metering timer (4 sec. to 30 min.).** This option allows you to specify how long the EOS T3i's metering system will remain active before switching off.
- **Grid display.** You can select Off, Grid #1, or Grid #2.
- **Video snapshot.** This is an easy way to create a set of movie clips, each lasting 2, 4, or 8 seconds. The T3i saves your snapshots to an album, each giving you a short movie that can be played back along with background music. Select Video Snapshot from the Movie 2 menu, and choose 2 sec. Movie, 4 sec. Movie, or 8 sec. Movie (or disable). Press SET to confirm your choice.

Movie menu 3 has five entries that have the same functions as their counterparts in the still photography Shooting menus, and are explained in Chapter 3. Those entries are Exposure Compensation, Auto Lighting Optimizer, Picture Style, White Balance, and Custom White Balance. I won't duplicate those descriptions here.

Capturing Video/Sound

To shoot movies with your camera, just follow these steps:

1. **Change to Movie mode.** Rotate the Mode Dial to the Movie setting.
2. **Focus.** Use the autofocus or manual focus techniques described in the preceding sections to achieve focus on your subject.
3. **Begin filming.** Press the Start/Stop button to begin shooting. A red dot appears in the upper-right corner of the screen to show that video/sound are being captured. The access lamp also flashes during shooting.
4. **Changing shooting functions.** As with Live View, you can change settings or review images normally when shooting video.
5. **Lock exposure.** You can lock in exposure by pressing the */Thumbnail/ Zoom Out button on top of the T3i, located just aft of the Main Dial. Unlock exposure again by pressing the button once more.
6. **Stop filming.** Press the Start/Stop button again to stop filming.
7. **View your clip.** Press the Playback button (located to the bottom right of the LCD). You will see a still frame with the clip timing and a symbol telling you to press the SET button to see the clip. A series of video controls appear at the bottom of the frame. Press SET again and the clip begins. A blue thermometer bar progresses in the upper-left corner as the timing counts down. Press SET to stop at any time.

GETTING INFO

The information display shown on the LCD screen when shooting movies is almost identical to the one displayed during Live View shooting. The settings icons in the left column show the same options, which can be changed in Movie mode, too, except that the Drive mode choice is replaced by an indicator that shows the current movie resolution and time remaining on your memory card.

Video Snapshots

Video snapshots are movie clips, all the same length, assembled into video albums as a single movie. You can choose a fixed length of 2, 4, or 8 seconds for all clips in a particular album. Activate the video snapshot feature in the Movie Shooting 2 menu, then follow these steps:

1. **Begin an album.** Press the Movie button. The T3i will begin shooting a clip, and a set of blue bars will appear at the bottom of the frame showing you how much time remains before shooting stops automatically.

2. **Save your clip as a video snapshot album.** A confirmation appears at the bottom of the LCD. Press the left/right cross keys to choose the left-most icon, Save as Album.

3. **Press SET.** Your first clip will be saved as the start of a new album.

4. **Shoot additional clips.** Press the Movie button to shoot more clips of the length you have chosen, and indicated by the blue bars at the bottom of the frame. At the end of the specified time, the confirmation screen will appear again.

5. **Add to album or Create new album.** Select the left-most icon again if you want to add the most recent clip to the album you just started. Alternatively, you can press the left/right cross keys to choose the second icon from the left, Save as a New Album. That will complete your previous album, and start a new one with the most recent clip.

6. **Delete most recent clip.** If you decide the most recent clip is not one you'd like to add to your current album, you can select Do Not Save to Album/Delete without Saving to Album (the right-most icon).

7. **Switch from Video Snapshots to conventional movie clips.** If you want to stop shooting video snapshots and resume shooting regular movie clips (of a variable length), navigate to the Movie Shooting 2 menu again, and disable Video Snapshot.

Playback and Editing

You can playback your video snapshots from the confirmation screen. Or, you can exit Movie mode and review your stills and images and play any of them back by pressing the Playback button located to the lower right of the LCD. A movie or album will be marked with an icon in the upper-left corner. Press the SET button to play back a movie or album when you see this icon.

As a movie or album is being played back, a screen of options appears at the bottom of the screen, as shown in Figure 6.7. When the icons are shown, use the left/right cross keys to highlight one, and then press the SET button to activate that function:

- **Exit.** Exits playback mode.
- **Playback.** Begins playback of the movie or album. To pause playback, press the SET button again. That restores the row of icons so you can choose a function.
- **Slow motion.** Displays the video in slow motion.
- **First frame.** Jumps to the first frame of the video, or the first scene of an album's first video snapshot.
- **Previous frame.** Press SET to view previous frame; hold down SET to rewind movie.
- **Next frame.** Press SET to view next frame; hold down SET to fast forward movie.
- **Last frame.** Jumps to last frame of the video, or the last scene of the album's last video snapshot.

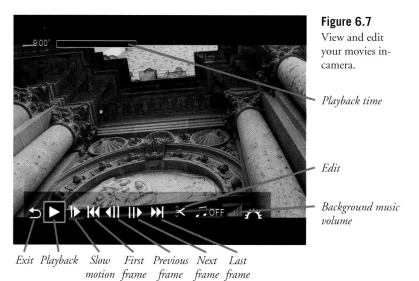

Figure 6.7
View and edit your movies in-camera.

Playback time

Edit

Background music volume

Exit Playback Slow First Previous Next Last
motion frame frame frame frame

- **Edit.** Summons an Editing screen.
- **Background music/volume.** Select to turn background music on/off. Rotate the Main Dial to adjust the volume of the background music.

The Editing Screen

While reviewing your video, you can select the scissor icon to trim from the beginning or end of your video clip. The icons that appear have the following functions:

- **Cut beginning.** Trims off all video prior to the current point.
- **Cut end.** Removes video after the current point.
- **Play video.** Plays back your video to reach the point where you want to trim the beginning or end.
- **Save.** Saves your video to the memory card. A screen appears offering to save the clip as a New File, or to Overwrite the existing movie with your edited clip.
- **Exit.** Exits editing mode.
- **Adjust volume.** Modifies the volume of the background music.

Tips for Shooting Better Video

There are a number of different things to consider when planning a video shoot:

Use a Shooting Script/Storyboards

A shooting script is nothing more than a coordinated plan that covers both audio and video and provides order and structure for your video. A detailed script will cover what types of shots you're going after, what dialogue you're going to use, audio effects, transitions, and graphics. A storyboard is a series of panels providing visuals that help you visualize locations, placement of actors/actresses, props, and furniture. It also helps show how you want to frame or compose a shot.

Advance a Story

A lot of the work will come after you shoot, when your video is assembled using a movie editing program like iMovie or Windows Movie Maker. Audio and video should always be advancing the story. While it's okay to let the camera linger from time to time, it should only be for a compelling reason and only briefly. It only takes a second or two for an establishing shot to impart the necessary information, and the same goes for a dramatic stare. Provide variety too. Change camera angles and perspectives often and never leave a static scene on the screen for a long period of time.

Keep Transitions Basic

Fancy transitions that involve exotic "wipes," dissolves, or cross fades take too long for the average viewer and make your video ponderous. Save dissolves to show the passage of time (it's a cinematic convention that viewers are used to and understand).

Composition

Movie shooting calls for careful composition, and, in the case of HD video format, that composition must be framed by the 16:9 aspect ratio of the format. Static shots where the camera is mounted on a tripod and everything's shot from the same distance are a recipe for dull videos. Try these tricks:

- **Establishing shot.** This composition, shown at left in Figure 6.8, establishes the scene and tells the viewer where the action is taking place.

- **Medium shot.** This shot is composed from about waist to headroom (some space above the subject's head). It's useful for providing variety from a series of close-ups and also makes for a useful first look at a speaker. (See Figure 6.8, right.)

- **Close-up.** The close-up, usually described as "from shirt pocket to head room," provides a good composition for someone talking directly to the camera. (See Figure 6.9, left.)

Figure 6.8

Figure 6.9

Figure 6.10

- **Extreme close-up.** This shot has been described as the "big talking face" shot. Styles and tastes change over the years and now the big talking face is much more commonly used (maybe people are better looking these days?) and so this view may be appropriate. (See Figure 6.9, right.)

- **"Two" shot.** A two shot shows a pair of subjects in one frame. They can be side by side or one in the foreground and one in the background. Subjects can be standing or seated. (See Figure 6.10, left.) A "three shot" is the same principle except that three people are in the frame.

- **Over the shoulder shot.** Long a tool of interview programs, the "over the shoulder shot" uses the rear of one person's head and shoulder to serve as a frame for the other person. This puts the viewer's perspective as that of the person facing away from the camera. (See Figure 6.10, right.)

Lighting for Video

Much like in still photography, how you handle light pretty much can make or break your videography. You can significantly improve the quality of your video by increasing the light falling in the scene. An inexpensive shoe mount video light, which will easily fit in a camera bag, can be found for $15 or $20. You can even get a good quality LED video light for less than $100. Work lights sold at many home improvement stores can also serve as video lights since you can set the camera's white balance to correct for any colorcasts. Much of the challenge depends upon whether you're just trying to add some fill light on your subject versus trying to boost the light on an entire scene. A small video light in the camera's hot shoe mount or on a flash bracket will do just fine for the former. It won't handle the latter.

Lighting can either be hard (direct) light or soft (diffused). Hard light is good for showing detail, but can also be very harsh and unforgiving. "Softening" the light, but diffusing it somehow, say, with an umbrella or white cardboard reflector, can reduce the intensity of the light but make for a kinder, gentler light as well.

Chapter 7

Shooting Tips

Here you'll find tips on settings to use for different kinds of shooting, beginning with recommended settings for some Playback, Shooting, and Custom Settings menu options. You can set up your camera to shoot the main type of scenes you work with, then use the charts that follow to make changes for other kinds of images. Most will set up their T3i for my All Purpose settings, and adjust from there.

Default, All Purpose, Sports—Outdoors, Sports—Indoors

	Default	All Purpose	Sports Outdoors	Sports Indoors
Exposure mode	Your choice	P	Tv	Tv
Autofocus mode	One-Shot	AI Focus	AI Servo	AI Servo
AF Point selection	Automatic	Automatic	Automatic	Automatic
Drive mode	Single Shooting	Single Shooting	Continuous Shooting	Continuous Shooting
Shooting menus				
Beep	Enable	Enable	Enable	Enable
Image Review	2 sec.	2 sec.	Off	Off
Peripheral illumination correction	Enable	Enable	Enable	Enable
Auto Lighting Optimizer	Standard	Standard	Disable	Disable
Metering mode	Evaluative	Evaluative	Evaluative	Evaluative
Color Space	sRGB	sRGB	sRGB	sRGB
Picture Style	Standard	Standard	Standard	Standard
ISO Auto	Auto	Auto	Max. 3200	Max. 3200
Set-up menus				
Auto power off	30 sec.	30 sec.	Off	Off
LCD auto off	Enable	Enable	Enable	Enable
Screen color	1	1	1	1
LCD brightness	Medium	Medium	Medium	Medium

Custom Functions

	Default	All Purpose	Sports Outdoors	Sports Indoors
C.Fn-1: Exposure level increments	0:1/3 stop	0:1/3 stop	0:1/3 stop	0:1/3 stop
C.Fn-2: ISO expansion	0:off	0:off	0:off	On
C.Fn-3: Flash sync. Speed in Av mode	0:Auto	0:Auto	0:Auto	2:1/200 (fixed)
C.Fn-4: Long exposure noise reduction	0:Off	0:Off	0:Off	0:Off
C.Fn-5: High ISO speed noise reduction	0:Standard	0:Standard	0:Standard	2:Strong
C.Fn-6: Highlight tone priority	0:Disable	1:Enable	0:Disable	0:Disable
C.Fn-7: AF-assist beam firing	0:Enable	0:Enable	1:Disable	1:Disable
C.Fn-8: Mirror lockup	0:Disable	0:Disable	0:Disable	0:Disable
C.Fn-9: Shutter/AE lock button	0:AF/AE lock	0:AF/AE lock	3:AE/AF, no AE lock	3:AE/AF, no AE lock
C.Fn-10: Assign SET button	0:Normal (disabled)	0:Normal (disabled)	0:Normal (disabled)	0:Normal (disabled)
C.Fn-11: LCD display when power ON	0:Display on	1:Previous display status	1:Previous display status	1:Previous display status

Stage Performances, Long Exposure, HDR, Portrait

	Stage Performances	Long Exposure	HDR	Portrait
Exposure mode	Tv	Manual	Tv	Tv
Autofocus mode	One-Shot	Manual	One-Shot	One-Shot
AF Point selection	Automatic	Automatic	Automatic	Automatic
Drive mode	Single Shooting	Single Shooting	Continuous Shooting	Continuous Shooting
Shooting menus				
Beep	Disable	Enable	Enable	Enable
Image Review	Off	Off	Off	2 sec.
Peripheral illumination correction	Enable	Enable	Enable	Enable
Auto Lighting Optimizer	Standard	Standard	Disable	Disable
Metering mode	Spot	Center-weighted	Evaluative	Center-weighted
Color Space	Adobe RGB	Adobe RGB	Adobe RGB	Adobe RGB
Picture Style	User - Reduce contrast, add sharpening	Neutral	Standard	Standard
ISO Auto	Max. 3200	Max. 3200	Auto	Auto
Set-up menus				
Auto power off	30 sec.	Off	Off	Off
LCD auto off	Enable	Enable	Enable	Enable
Screen color	1	1	1	1
LCD brightness	Dimmer	Dimmer	Medium	Medium

	Stage Performances	Long Exposure	HDR	Portrait
Custom Functions				
C.Fn-1: Exposure level increments	0:1/3 stop	0:1/3 stop	0:1/3 stop	0:1/3 stop
C.Fn-2: ISO expansion	1:On	1:On	0:Off	0:Off
C.Fn-3: Flash sync. Speed in Av mode	0:Auto	0:Auto	0:Auto	0:Auto
C.Fn-4: Long exposure noise reduction	2:On	2:On	0:Off	0:Off
C.Fn-5: High ISO speed noise reduction	2:Strong	2:Strong	0:Standard	0:Standard
C.Fn-6: Highlight tone priority	1:Enable	1:Enable	0:Disable	1:Enable
C.Fn-7: AF-assist beam firing	1:Disable	1:Disable	1:Disable	1:Disable
C.Fn-8: Mirror lockup	0:Disable	0:Disable	0:Disable	0:Disable
C.Fn-9: Shutter/AE lock button	0:AF/AE lock	0:AF/AE lock	3:AE/AF, no AE lock	3:AE/AF, no AE lock
C.Fn-10: Assign SET button	0:Normal (disabled)	0:Normal (disabled)	0:Normal (disabled)	0:Normal (disabled)
C.Fn-11: LCD display when power ON	0:Display on	1:Previous display status	1:Previous display status	1:Previous display status

Studio Flash, Landscape, Macro, Travel, E-Mail

	Studio Flash	Landscape	Macro	Travel	E-Mail
Exposure mode	Manual	Av	Tv	Tv	Av
Autofocus mode	One-Shot	One-Shot	Manual	One-Shot	One-Shot
AF Point selection	Automatic	Automatic	Automatic	Automatic	Automatic
Drive mode	Single Shooting	Single Shooting	Single Shooting	Single Shooting	Single Shooting
Shooting Menus					
Beep	Enable	Enable	Enable	Disable	Enable
Image Review	2 sec.	2 sec.	Off	Off	2 sec.
Peripheral illumination correction	Enable	Enable	Enable	Enable	Enable
Auto Lighting Optimizer	Standard	Standard	Standard	Standard	Standard
Metering mode	Manual	Evaluative	Spot	Evaluative	Evaluative
Color Space	Adobe RGB	Adobe RGB	Adobe RGB	sRGB	sRGB
Picture Style	Standard	Vivid	Standard	Vivid	Vivid
ISO Auto	Auto	Auto	Auto	Auto	Auto
Set-up menus					
Auto power off	Off	Off	Off	30 sec.	30 sec.
LCD auto off	Enable	Enable	Enable	Enable	Enable
Screen color	1	1	1	1	1
LCD brightness	Medium	Medium	Medium	Medium	Medium

	Studio Flash	Landscape	Macro	Travel	E-Mail
Custom Functions					
C.Fn-1: Exposure level increments	0:1/3 stop	0:1/3 stop	0:1/3 stop	0:1/3 stop	0:1/3 stop
C.Fn-2: ISO expansion	0:Off	0:Off	0:Off	0:Off	0:Off
C.Fn-3: Flash sync. Speed in Av mode	0:Auto	0:Auto	0:Auto	0:Auto	0:Auto
C.Fn-4: Long exposure noise reduction	0:Off	2:0n	2:On	0:Off	0:Off
C.Fn-5: High ISO speed noise reduction	0:Standard	0:Standard	0:Standard	0:Standard	0:Standard
C.Fn-6: Highlight tone priority	1:Enable	1:Enable	0:Disable	1:Enable	1:Enable
C.Fn-7: AF-assist beam firing	1:Disable	1:Disable	0:Enable	0:Enable	0:Enable
C.Fn-8: Mirror lockup	0:Disable	0:Disable	0:Disable	0:Disable	1:Enable
C.Fn-9: Shutter/AE lock button	0:AF/AE lock	0:AF/AE lock	0:AF/AE lock	0:AF/AE lock	0:AF/AE lock
C.Fn-10: Assign SET button	0:Normal (disabled)	0:Normal (disabled)	0:Normal (disabled)	0:Normal (disabled)	0:Normal (disabled)
C.Fn-11: LCD display when power ON	0:Display on	1:Previous display status	1:Previous display status	1:Previous display status	1:Previous display status

Index

M